THE ART OF THREE-DIMENSIONAL DESIGN

LOUIS WOLCHONOK

THE ART OF THREE-DIMENSIONAL DESIGN

HOW TO CREATE SPACE FIGURES

by the author of *Design for Artists and Craftsmen*

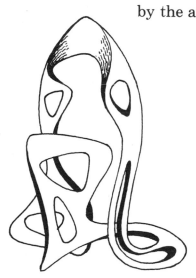

DOVER PUBLICATIONS, INC., NEW YORK

Published in Canada by General Publishing Company, Ltd., 30 Lesmill Road, Don Mills, Toronto, Ontario.
Published in the United Kingdom by Constable and Company, Ltd., 10 Orange Street, London WC 2.

This Dover edition, first published in 1969, is an unabridged and unaltered republication of the work originally published by Harper and Brothers, Publishers, in 1959.
This edition is republished by special arrangement with Harper & Row, Publishers.

Standard Book Number: 486-22201-2
Library of Congress Catalog Card Number: 75-86322

Manufactured in the United States of America
Dover Publications, Inc.
180 Varick Street
New York, N.Y. 10014

To
E. H. W.

CONTENTS

PREFACE

This book is the outgrowth of more than twenty-five years of study, observation and active participation as teacher and creative artist.

The mature person, whether interested in art as a profession or an avocation, realizes, as he gains proficiency in technical expression, that there is always more to learn. He is eager to take the time and make the effort to widen his powers of expression so that he can do justice to his ideas.

It has been my practice as a teacher to present a challenge to my students. Each one of them, a distinct individual, has been made to feel that his individuality, precious and rare, could be preserved in his work if he would explore, study, and experiment with the basic forms that are "in the public domain."

The basic geometric space figures presented in this book are modified and transformed in ways that make use of the inherent properties of the figures. By studying the properties of the basic figures, we can discover more ways to give tangible form to our ideas. The study of basic forms is a continuing one, whether we deal with natural or geometric form. We take time out, so to speak, to fix in our minds the things we have learned about shapes, movement, and technique. Then we reach a point in our creative efforts when we seem to have exhausted ourselves. We repeat too much. The sparkle in our work has been dimmed. The efforts show strain. It is at such a time as this that we must stop and go back to source material if we are to revitalize our work.

About three years ago I saw a movie short showing the great French master Matisse sketching leaves and flowers in his garden. Henri Matisse was in the waning years of his life, yet he said that he could see something new each time he looked at his plants. This remark from a man who had been drawing, painting, and modelling for over seventy years!

Study the text and the accompanying illustrations. Give special attention to the parts that interest you least. It may seem paradoxical, but the discipline required to do this will benefit all of your work.

The illustrations are my work and they are original. They are intended only as guides. Create your own figures; whenever possible, make three-dimensional models.

There is no short cut to fulfillment. There is the magical

quality of retaining one's enthusiasm. There is work and more work, observation, study, and experimentation to be done.

I hope this book will help you in your efforts toward self-expression.

NEW YORK CITY THE AUTHOR

THE ART OF THREE-DIMENSIONAL DESIGN

1. INTRODUCTION

Any object or geometric magnitude that has length, breadth, and thickness is three-dimensional. The three-dimensional or space object has the property of envelopment; that is, it may be incased in a rectangular prism whose faces will be tangent to the extreme limits of the space object.

There are many different types of three-dimensional objects. The differences for the most part are explained by the geometric properties that characterize each type.

We must realize that when we talk about geometric properties we talk about imaginary conditions. The objects and surfaces with which we deal in real life are our own approximations of the mathematical concepts. It is well to remember that the mathematical line or surface or object is one thing and its counterpart in reality is quite another thing.

From a practical point of view, the closer we try to make an object or surface or line conform to its mathematical equivalent the more exact we must be in both tooling and measuring. As a result the economic factor enters the picture. Strange as it may seem, the economics of the situation may have a very profound effect on the design. Any designer working in industry knows only too well the intimate relationship between design and economics and the challenging problems that must be overcome for a satisfactory solution. As an example, an industrial

designer may be called upon to create a design which can be produced by casting or die-stamping. If the concern does not have a foundry and does not wish to parcel out its jobs, the designer is confronted with a problem different from the one which he would otherwise have if casting were feasible.

The question of how to construct the object and what materials to use is ever present when dealing with three-dimensional design. Essential as this is, this book is primarily concerned with an investigation into the properties of surfaces, their modification, adaptation, and transformation into new forms.

In the course of everyday living we see countless objects with the greatest variety of shapes and functions. As a matter of interest and curiosity, count the number of differently shaped objects that you see in your own home. Do the same when you are out-of-doors. I am quite sure that you will be astonished at the large number of space objects that you see, that you live with, that you use—each one in some mysterious way adding to the sum total of your ever-widening experience.

What are the basic shapes or surfaces? How can they best be described for the profitable use of the designer? How can they be combined and modified to serve the purposes of the designer? This book tries to answer these questions. We must bear in mind, however, that design involves much more than an understanding of the basic geometric properties of space objects.

It includes as well:
1. An awareness of, and knowledge concerning, the properties of various types of material.
2. The availability of tools for manufacture.
3. The availability of skilled craftsmen.
4. Knowledge of municipal and state codes which impose restrictions affecting design.
5. The ability to cultivate a reasonable attitude toward the ideas of others with whom it may be necessary to collaborate on a design project. (This is especially important in production and architectural design.)
6. A questioning outlook not easily satisfied by any ready-made solution.
7. A healthy disrespect for historic design. (This does not mean that we must deny the greatness of earlier forms in order to proceed with the solutions to our own problems.)

8. A healthy curiosity and a desire for continuing inquiry into the essential nature of source material.

Each designer has his own limited capacity for self-expression. At each step of his development he acquires new skills and new emotional outlooks which come from the subtle influences of the works of others and from his own continuing growth. He constantly calls on all of his resources to give fullest expression to his ideas. Only after he is adequately prepared can he bring into play the imagination, the technical skill, the daring that each design must have in order to do justice to its creator.

2. FUNDAMENTAL DEFINITIONS

1. *A line* A line is a geometric figure created by a point moving through successive positions.

Straight line The direction remains the same throughout the length of the line.

Broken line Each successive segment changes direction.

Curved line There is a constant change in direction. The direction at any point in the curve is described by the direction of the tangent line at that point.

2. *Plane surface* A plane surface is a geometric magnitude produced by the motion of a *straight* line. The moving straight line always passes through a fixed point and always intersects a fixed straight line.

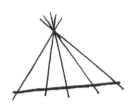

3. *Prismatic surface* A prismatic surface is a combination of plane surfaces in which the successive planes change direction. It is produced by a straight line moving parallel to a fixed straight line and always touching a fixed broken line.

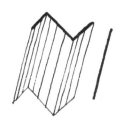

4. *Cylindric surface* A cylindric surface is generated by a straight line moving parallel to a fixed straight line and always touching a fixed curved line.

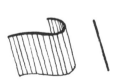

5. *Pyramidal surface* A pyramidal surface is a combination of plane surfaces having a common point. It is created by a straight line moving through a fixed point and always touching a fixed broken line.

6. *Conical surface* A conical surface is created by a straight line moving through a fixed point, always touching a fixed curved line.

7. *Surface of revolution* A surface of revolution is formed by the motion of a line about a straight line axis. Each point of the moving line generates a circle. The moving line may be straight, curved, or a combination of the two.

8. *Spherical surface* The spherical surface is a surface of revolution. It is formed by the rotating motion of a circle about one of its diameters.

9. *Toroidal surface* A toroidal surface is a surface of revolution created by the rotating motion of a curve about a straight line lying outside the curve. If the curve is a circle, the surface is called an *annular torus*.

10. *Hypoid surface* A hypoid surface is a surface of revolution formed by the motion of one straight line about a second straight line as the axis. (The two straight lines are non-parallel and non-intersecting. They are called *skew lines*.)

11. *Hyperbolic paraboloid surface* A hyperbolic paraboloid is a surface generated by a moving line that always touches two skew lines and is always parallel to a fixed plane.

12. *Conoid surface* The conoid is a surface created by a line moving so that it always touches a fixed straight line and a fixed curve and is always parallel to a fixed plane.

13. *Helicoid surface* The helicoid is a surface generated by a line moving so that it touches a helical curve and makes a constant angle with a fixed straight line axis of the helix.

14. *Convolute surface* The convolute is a surface formed by the tangents to a space curve.

15. *Serpentine surface* The serpentine is a surface formed by the successive positions of a sphere as the center of the sphere moves along a curved line.

3. THE PLANE SURFACE

The plane surface may be generated in a number of different ways. Two of the most easily understood are:

1. Assume any straight line and any point lying outside the straight line. A second straight line is now introduced and moved through an infinite number of positions *always* passing through the fixed point and *always* intersecting the fixed straight line.

The sum of all the positions of the moving line is called a plane surface.

fig 1 fig 2

2. Assume two parallel straight lines. Introduce a third straight line intersecting the parallel lines. Move the third straight line parallel to its initial position, *always* touching the two fixed parallel straight lines.

The sum of the infinite positions of the moving line is called a plane surface.

The concept of motion as expressed in the definition of the plane surface adds a dynamic quality to this geometric magnitude.

In all of the fundamental statements regarding the various types of surfaces considered in this book, motion of a line, whether straight or curved, plays an important role. In a sense, the successive positions of the moving line generator are like the skeleton of an animal figure. Many examples of contemporary art show the surfaces uncovered, so to speak, and the positions of the generating line exposed. This so-called exposure heightens the feeling of motion because it enables the eye to go from position to position. It is the change of position that induces a sense of motion.

The plane surface considered by itself is two-dimensional. We know that it is composed of an infinite number of straight

lines. The plane surface may also be composed of an infinite number of plane curves, open and closed, and all sorts of combinations of straight and curved lines.

In fig. A, all of the lines, heavy as well as light, lie in the same plane.

fig A

All that we have to do to add the third dimension and produce a space figure is to take one of the infinite lines, or part of one, out of the plane. The combination of the plane surface and the line out of the plane surface constitutes a space figure having three dimensions.

The perspective drawing in fig. B shows the effect of moving several lines out of the plane.

fig B

Keeping in mind the general nature of a plane surface, we see that there are many apparently complex space figures which can be evolved from combinations of plane surfaces and elements taken from the plane surfaces.

The plane surface, and combinations of plane surfaces with elements from them, occur most frequently in man-made objects. The plane surface in nature is a rarity, at least in ordinary visual experience. For example, crystals are very common in nature, and their geometric faces are plane surfaces; but unless the crystals are very large, the faces cannot be seen.

4. BASIC SURFACES

PLATES

A. Surfaces composed of planes and singly ruled developable surfaces.

B. Non-developable surfaces. (Variation 6, the convolute, is an exception.) Variations ID and 3 show the internally tangent spheres.

PLATE A Types of surfaces.

All of the surfaces shown in Plate A are called *ruled surfaces,* i.e., surfaces generated by the motion of a straight line.

Figures 1, 2, and 3 are prismatic surfaces; Figures 4, 5, and 6 are pyramidal surfaces.

Each of the six surfaces is composed of planes for the faces. The number of faces is limitless.

Figure 1 is an oblique prism: The lateral edges do not make right angles with the plane of the base.

Figure 4 is an oblique pyramid: The axis—the line joining the apex and the center of the base—is not the same length as the altitude, which is the perpendicular line from the apex to the base.

The development or pattern accompanying each figure represents the surface unrolled. Only ruled surfaces can be developed without tearing or stretching the surface.

Figures 7, 8, and 9 represent cylindric surfaces; Figures 10, 11, and 12 represent conical surfaces.

Figures 7 and 10 are oblique for the same reasons given for Figures 1 and 4, above.

Since both the cylindric and conical figures are ruled surfaces, they may be unrolled to form patterns or developments.

Note: Every developable surface is a ruled surface but not every ruled surface is a developable surface. For example, both the hypoid and hyperbolic paraboloid surfaces are ruled surfaces, but they cannot be developed without stretching, tearing, or somehow deforming the surface, making it impossible to restore the surface to its original shape.

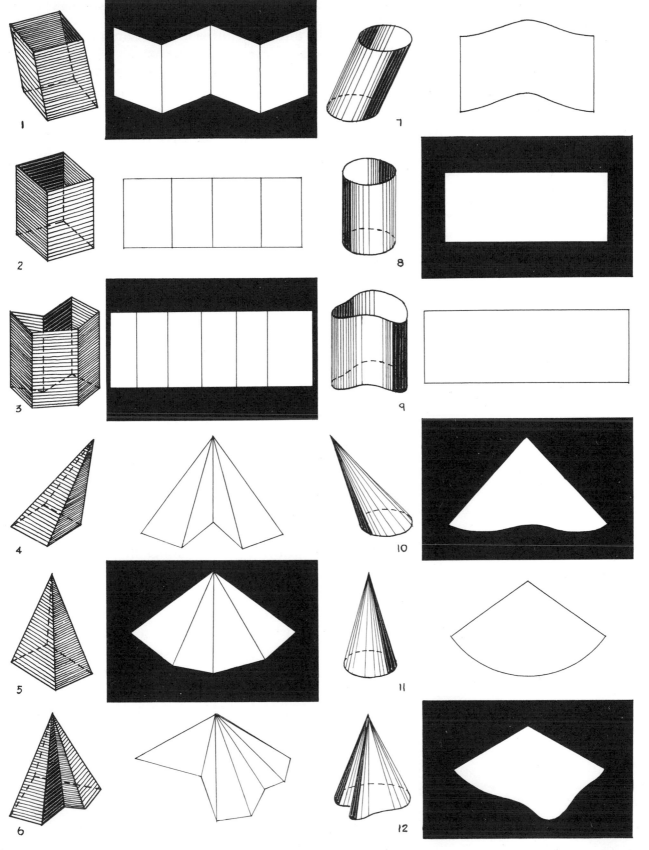

PLATE B **Ruled surfaces and non-ruled surfaces.**

Figures 1A, 1B, 1C, and 1D represent the same figure, the hypoid or hyperboloid.

The extreme contour shows the characteristic hyperbolic curve. It is a ruled surface, as shown in Figure 1A. In general, the hypoid surface can be generated by the rotation of one straight line (the generator) about a second straight line (the axis of rotation). The common perpendicular distance between the two lines must be constant and, furthermore, the two lines must be skew. (Skew lines are lines which do not determine a plane surface.)

In Figure 1A, successive positions of the moving generator are shown. Every point on the generator moves in the path of a circle and the plane of the circle is perpendicular to the axis (the fixed line).

Figure 1B shows the same hypoid generated by the rotation of a meridian section about the axis. (Any plane containing the axis of a surface of revolution is called a meridian section.)

Figure 1C shows the parallel circles, each of which represents the path of a point, as the hyperbolic line on which the point is situated rotates about the axis.

Figure 1D shows the same hypoid with a series of internally tangent spheres. The envelope of the spheres forms the hyperboloid surface.

There are other ways in which the hypoid surface may be generated. This is true for many of the surfaces that are mentioned, but a complete discussion of the analytic and descriptive properties of the various figures belongs in books on analytic and descriptive geometry and is beyond the scope of this work.

Figure 2 is called a conoid. The conoid is a ruled non-developable surface generated by the motion of a straight line always touching a fixed curved line and a fixed straight line (the fixed lines not in the same plane) and always parallel to a fixed plane surface.

Figure 3 is called a serpentine. The serpentine surface is the envelope of an infinite number of spheres whose centers are on a curve and whose diameters are constant. The serpentine is not a ruled surface, hence not developable.

Figure 4 is a hyperbolic paraboloid. This is a non-developable ruled surface generated by the motion of a straight line

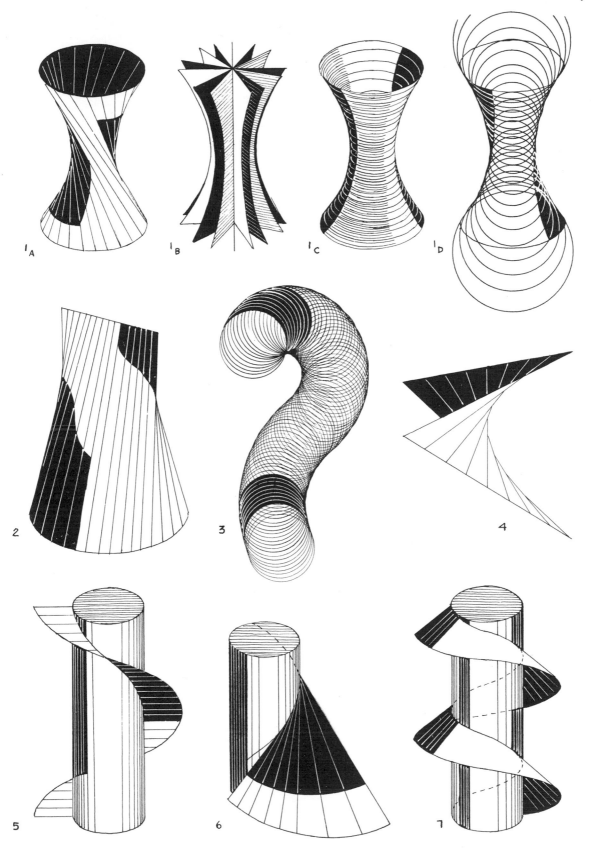

always touching two straight skew lines and always parallel to a plane surface.

Figure 5 is the right helicoid. It is a non-developable surface generated by a straight line touching two co-axial helices and at right angles to the axis.

Figure 7 is the oblique helicoid. It is a non-developable surface generated by a straight line touching two co-axial helices and making a constant angle other than a right angle with the axis. (Strictly speaking, the angle that the generator makes with the axis need not be constant. However, this fact does not affect the basic nature of the surface.)

Figure 6 is a convolute. This is a developable surface generated by a straight line moving so that it is always tangent to a space curve. In the illustration, the space curve is a helix (the curve that winds around a cylinder).

5. THE PRISM AND PRISMATIC SURFACES

PLATES

A. Surfaces whose faces are varied figures of three or more sides.
B. Sheet and wire-combining forms.
C. The dynamic diagonal in the skeletal wire prism.
D. The prismatic module—combinations varying in size and shape.
E. Plane surface angular variants from the square prism (tile design).
F. Further variants including cylindric surfaces (tile design).
G. Variations in over-all shape through rearrangement of prismatic parts, keeping the total volume constant.

Michelangelo once said that all the sculptor had to do was to remove the excess material to reveal the figure that is hidden in the marble block. The concept of removing or subtracting from the whole can be applied to any fundamental solid. It is obvious that the figure or figures which will reveal themselves are infinite in their variety and await only the imagination and technical skill of the creator to bring them to life.

I am using the term "figure" in its most inclusive sense. It embraces the simplest geometric form and the most complex combination of animal and human forms.

I have confined myself in the following illustrations to geometric combinations because:

1. Simple geometric figures are easiest to imagine and construct.
2. They are the easiest to control and describe.

In the illustrations marked D, page 17, the process of *addition* is used to bring a three-dimensional object into being. We can see that the line which is caused by the moving point "A," as it changes both direction and length, develops a space form. The general character of this form is controlled by the extent to which the moving point "A" is permitted to move.

The additive process is more common than the subtractive one in actual practice. In order that we may learn more about the essential nature of fundamental solids and how we may best make use of the singular properties inherent in each one of them, we must experiment in every possible way.

The total three-dimensional object may be a combination of both addition and subtraction; in the development of space figures, a combination of both processes is most often used. The designer's problem is not merely one of adding to, nor of subtracting from, but rather of working out a total object

whose parts lend emphasis to the whole and whose overall aspect is an harmonious, integrated arrangement of related parts.

Consider the following prism (AA). The upper and lower bases are rectangles. I have chosen this solid merely for convenience; the bases may have three, four, or any number of sides.

AA

A 1

2

3

4

A. Think of the prism as made up of a great many smaller prisms. (Cuts parallel to edges.)

1 B

2

B. The prism may be subdivided into combinations of pyramids and prisms.

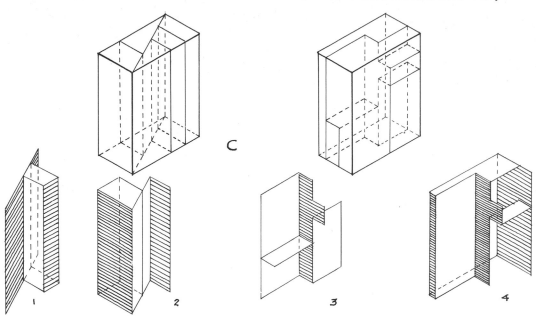

C. The prism may be divided into combinations of prisms and plane surfaces. In actual practice, the plane surface becomes a thin sheet.

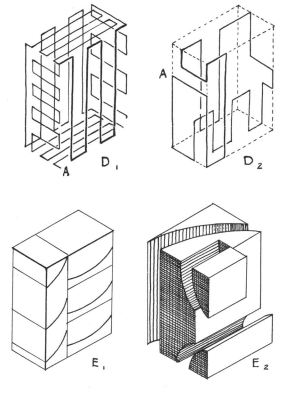

D. Consider the prism as evolved from a moving point "A," that forms a succession of straight lines. The straight lines produce a series of plane surfaces.

E. The prism may be subdivided into segments by cuts producing combinations of plane and cylindric surfaces.

F. Think of the prism as being composed of segments produced by spherical cuts.

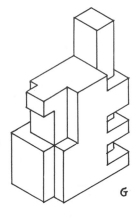

G. Evolve space shape by addition and subtraction.

Further considerations in the evolution of space figures derived from the basic prism concern changes in direction, changes in relative sizes, and changes in transition surfaces.

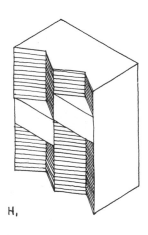

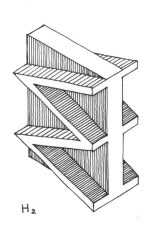

H. Changes in direction.

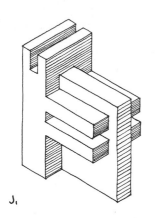
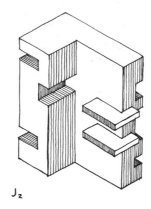

J₁ J₂

J. Changes in relative sizes.

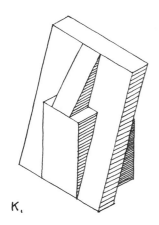
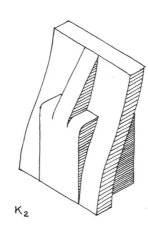

K₁ K₂

K. Changes in transition surfaces.

Milton Glaser

PLATE A **Surfaces whose faces are varied figures of three or more sides.**

The prism and the pyramid are the only solids whose surfaces are composed of plane figures. In this plate, Figure 1 shows how the plane surface is generated. The theoretical surface is limitless in length and width, and any finite plane figure may be drawn in it.

The pyramidal figures in this plate (Figure B and all those numbered 2) are introduced to show graphically the essential differences between pyramidal and prismatic figures, and to emphasize the stark contrasts in the directions of the adjacent planes of each type of figure.

All of the other basic surfaces in this book are curved.

In the all-prismatic surfaces, as shown in Figure A and all those numbered 3, the lateral edges (lines common to any two adjacent faces) are parallel to each other. This is the most important distinguishing feature of the prismatic surface. The unequal lengths of the lateral edges in Figure 4 are produced by a cut oblique to the base of the prism. This cut does not change the fundamental character of the figure.

Figure 5 shows the prism and pyramid combined, and highlights the differences between them.

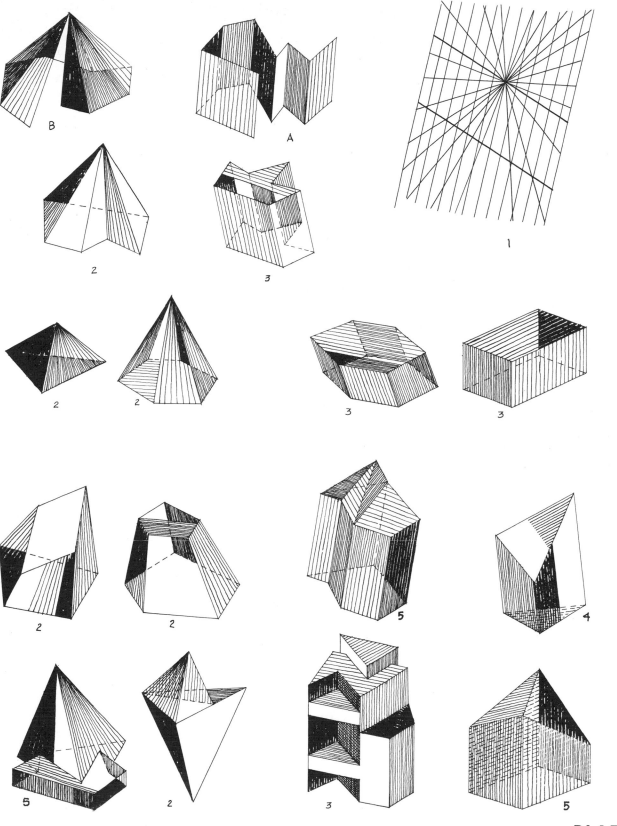

PLATE A

PLATE B **Sheet and wire-combining forms.**

Every solid is composed of an infinite number of lines, planes, curved surfaces, and lesser volumes varied in size and shape. The sum of all of them in the correct order gives us the basic solid. If the order is changed, or if any of the lesser volumes are removed, a new type of solid is created. This holds true whether we are dealing with a prism or a pyramid, in which the faces are plane surfaces, or whether we are concerned with a sphere or an ellipsoid, whose surfaces cannot contain a straight line.

The sphere and ellipsoid have *inner* parts, and it is in these inner parts that we can get straight edges. This simple fact is often overlooked, but the truth is that if we fix it in our minds, we have a very valuable tool at our command for the problem of converting basic figures into design forms.

In Plate B, lines and planes inherent in the basic rectangular prism have been combined to form space figures of varying conformation. The distribution of black, white, and gray values has been employed merely to heighten the three-dimensional quality of each figure.

Wide avenues of practical value are opened by this approach to the problem of using basic forms. Note that the directions of lines and surfaces within the prisms are parallel to the faces and edges of the basic rectangular block. This was done purposely in order to maintain a measure of control while experimenting.

Note also that the right angularity of all surfaces has been kept.

Try the following:
1. A series of open figures maintaining parallelism and right angularity.
2. A series of open figures with changing surface contours.
3. A series of open figures using oblique surfaces in combination with oblique and right-angled lines.
4. A series of partially open figures using the greatest possible variety of lines and surfaces. See figs. 1 and 2 left, for example.

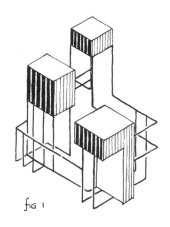

fig 1

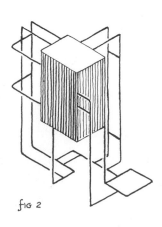

fig 2

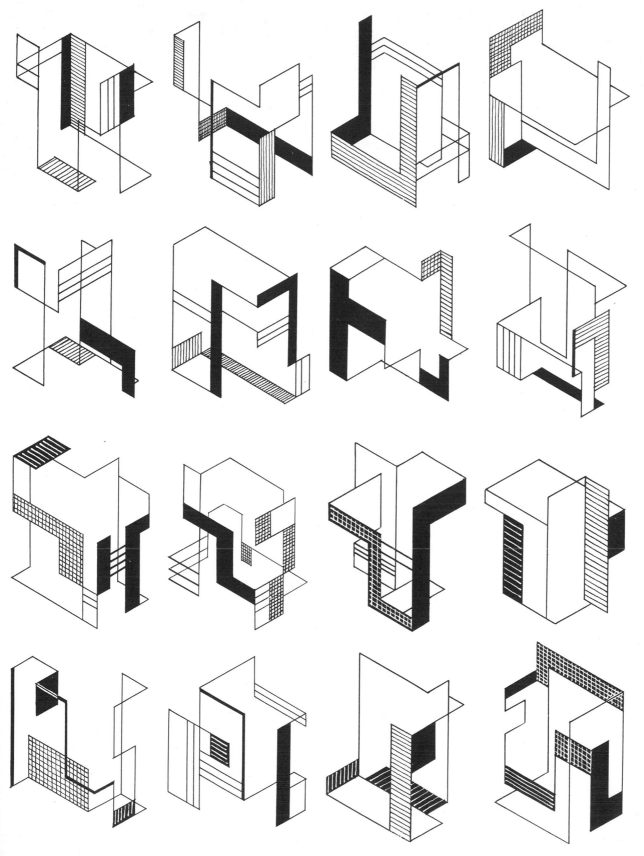

PLATE B

PLATE C **The dynamic diagonal in the skeletal wire prism.**

In this plate, the nine variations show an extension of the method dealt with in Plate B. The dynamic diagonal line is introduced, and the right angularity of the rectangular prism has been modified. The departure from the ever-recurring right angle makes for a more lively design. Some of the diagonals used have been derived in the following way:

1. Consider the prism with its corners lettered (fig. 1). We now have the lateral face diagonals DF, EC, DH, AE, AG, BH, BF, and CG. We have base diagonals AC, DB, HF, and EG. Prism diagonals are DG, BE, AF, and CH.

2. Now consider the prism with subdivisions of the faces to form new series of diagonals (fig. 2). Point J is the midpoint of BC; point K is the midpoint of DE; point L is the midpoint of HE; point M is the midpoint of BG.

In addition to the diagonals shown in fig. 1, we now have a generous increase in the number of oblique lines. This in turn makes it possible to transform the basic rectangular block into many variants.

Go to the nine examples in Plate C and discover the subdivisions underlying each design.

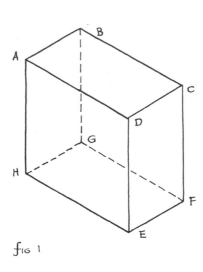

fig 1

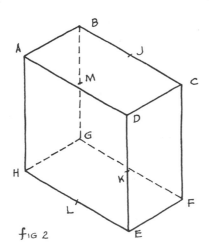

fig 2

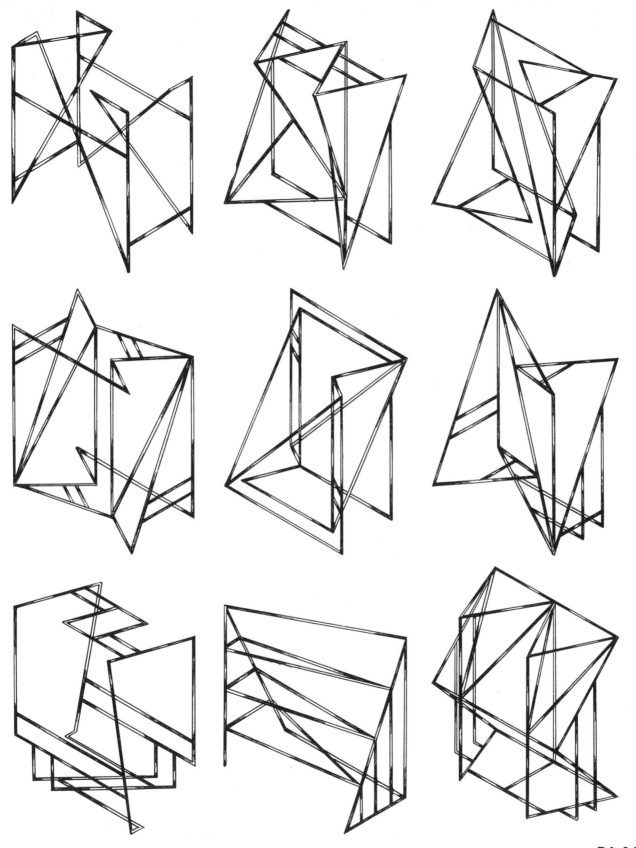

PLATE C

PLATE D The prismatic module—combinations varying in size and shape.

Figures 1, 2, 3, and 4 show the basic rectangular blocks and their subdivisions. These have been combined in a number of different ways to form Figures 5, 6, 7, 8, 9, 10, and 11.

Figures 5 and 6 are derived from Figure 1.

Figures 7 and 9 are derived from Figure 2.

Figures 8 and 10 are derived from Figure 3.

Figure 11 is derived from Figure 4.

The basic figures 1, 2, 3, and 4 illustrate how subdivisions of the rectangular block may be used to create new combinations.

Remember that each part may be enlarged, reduced in size, repeated, and shifted in position.

If we subdivide the rectangular blocks by means of cuts oblique to the edges, we have new volumes that will completely alter the character of the whole design. For example, figs. 1, 2, and 3 below. Each cut in the three examples shown below is oblique to the lateral edges of the basic rectangular block.

We can now use the new odd-shaped volumes together with the remaining parts of the basic block to invent new forms.

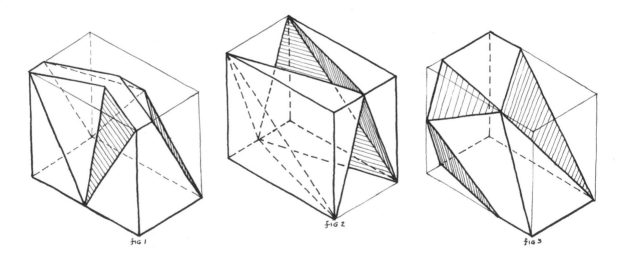

fig 1 fig 2 fig 3

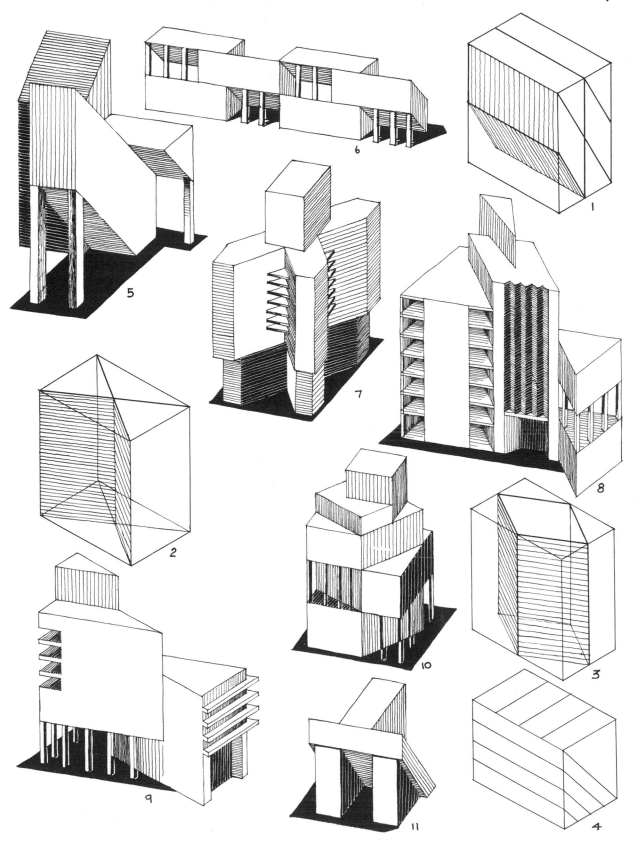

PLATE E **Plane surface angular variants from the square prism (tile design).**

The six examples in this plate show how a rectangular block is transformed by the removal of a series of volumes having straight edges and plane faces. The same figures can be produced by stamping or casting. If sheet metal, such as aluminum, is used, we may easily imagine these sections as forming the facing on a building. They can be used as ceramic tiles and can be produced in quantity by casting. They are designed so that when repeated they form a continuous pattern.

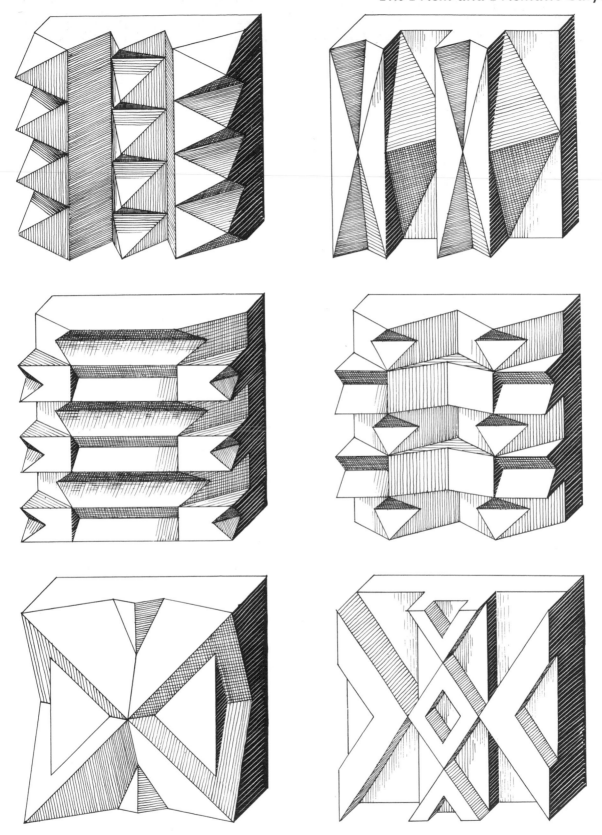

PLATE F Further variants including cylindric surfaces (tile design).

In this plate, only one of the examples uses all straight edges and plane surfaces. The remaining blocks use a combination of plane and cylindric surfaces. Figure 4, in addition to the plane and cylindric surfaces, uses spherical surfaces. Figures 1, 2, and 3 are asymmetrical.

The geometric designs of both Plates E and F, for the most part, have bilateral symmetry. Effective asymmetric geometric design may also be used. When we consider a block as a distinct separate unit, the asymmetric aspect of the design assumes an importance that is somewhat lessened when the same block is repeated as an over-all pattern. The repetition gives a regularity to the design that the individual block does not have.

Create a series of block or tile designs using:

1. All plane surfaces with uniform depth of cut; all plane surfaces with variations in depth of cut.
2. All cylindric surfaces.
3. Combination of plane and cylindric surfaces.
4. All spherical surfaces.
5. Combination of plane, cylindric, and spherical surfaces.

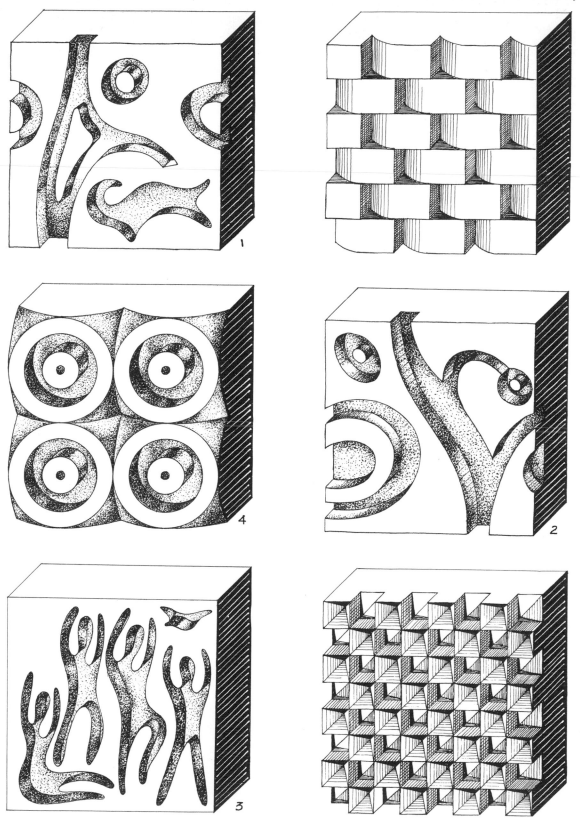

PLATE F

PLATE G **Variations in over-all shape through re-arrangement of prismatic parts, keeping the total volume constant.**

The basic shape of the solid is the rectangular pyramid. In Figure 1 we see the whole block with Figure 1A removed.

Figures 1B, 1C, and 1D show subdivisions of Figure 1A.

Each of the thirteen examples shows a different arrangement of the blocks having the same volume. If we divide the basic block into different units, we have further material for conversion into interesting composites. If we get away from the right-angled blocks, the number of possible combinations is increased even more.

We must not lose sight of the problem of maintaining the same volume throughout this exercise. This qualification offers a challenge to the designer that he may run across in actual practice.

Use the combinations shown in the examples below and create some of your own.

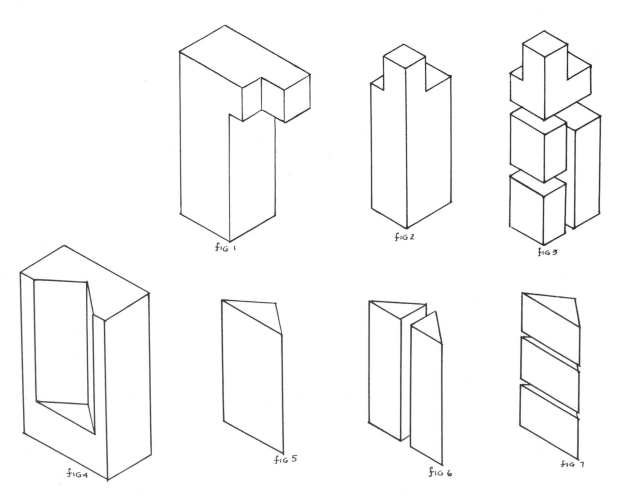

fig 1 fig 2 fig 3

fig 4 fig 5 fig 6 fig 7

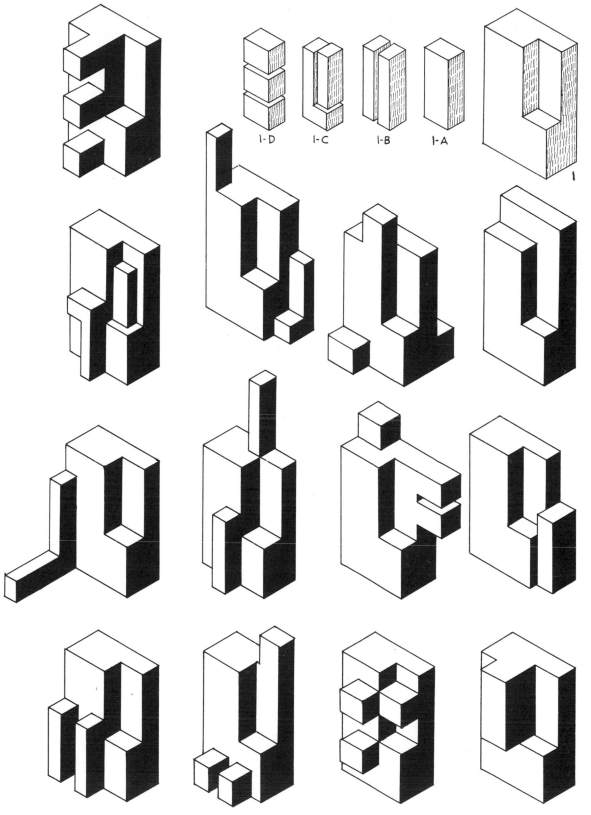

1-D 1-C 1-B 1-A

1

6. CYLINDRIC SURFACES

PLATE

A. Combining surfaces in which the cylindric surface is featured.

The cylindric surface is a surface generated by the motion of a straight line moving so that it is always parallel to a fixed straight line and always touching an open or closed curve. (The fixed straight line and the curve must not lie in the same plane.) For examples, see figs. A–G.

fig A

fig B

fig C

fig D

fig E

fig F

fig G

If we start with a rectangular plane sheet such as fig. 1, it can be converted into a cylindric surface by rolling. If the sheet is rolled along element AB, we get fig. 2. If it is rolled along element CD, we get fig. 3. If it is rolled along element FE, we get fig. 4.

The lines AB and CD become helices. The rolling element always remains a straight line parallel to its initial position.

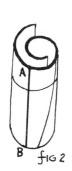

fig 2

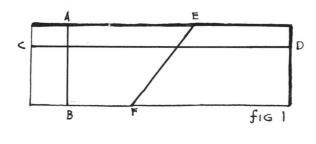

fig 1

fig 3

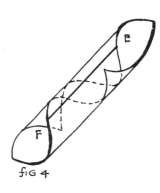

fig 4

PLATE A **Combining surfaces in which the cylindric surface is featured.**

Figures 4 and 6 are made up of a preponderance of cylindric surfaces but they also have several helicoidal surfaces. (The twisted surface is helicoidal.)

Figures 7 and 9 are altogether cylindric.

Figures 1, 2, 3, 5, and 8 are combinations of cylindric and plane surfaces with emphasis on the cylindrics.

In Figures 3 and 8, cutting planes oblique to the axis of the right cylindric surfaces produce elliptical sections.

A cut at right angles to the axis of a right circular cylinder produces a circle.

A cut parallel to the axis of a right circular cylinder produces a rectangle, and if the right circular cylinder is open top and bottom, the section cut consists of two elements of the cylinder. (Elements are straight lines of the surface parallel to the axis.) Intersecting cylindric surfaces produce interesting lines of intersection which can be combined with straight and curved lines to create new forms.

Fig. A shows how cylinders intersect. Fig. B shows the line of intersection, which is a space curve, unique in that two different sets of parallel lines can join all the points on the curve.

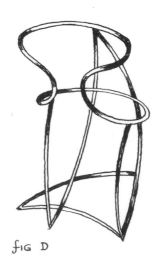

fig A

fig B

Using the same curve that appears in fig. B, we can, by the addition of different kinds of lines, evolve new figures. See figs. C and D, for example.

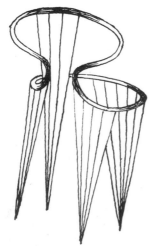

fig C

fig D

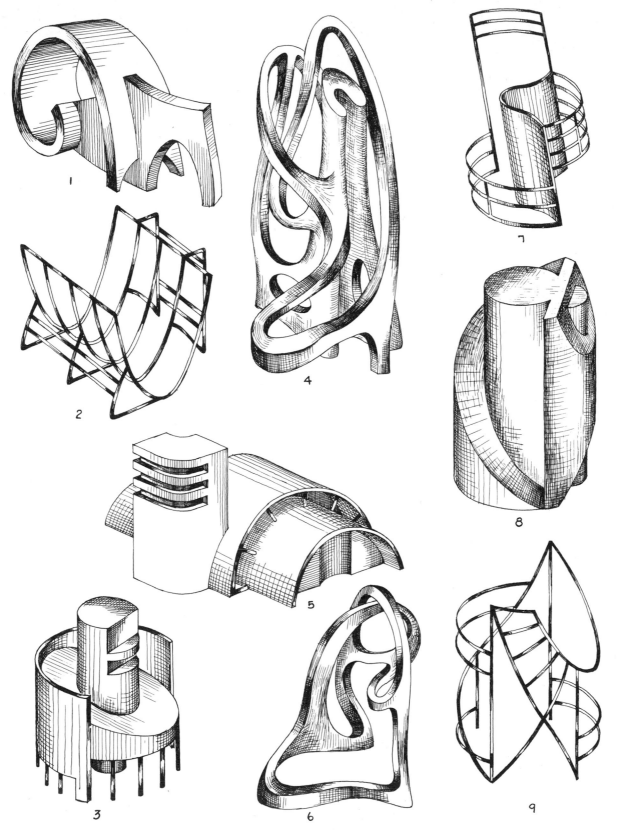

7. THE PYRAMID AND PYRAMIDAL SURFACES

PLATES

A. Open pyramidal figures using line elements and partial surfaces.
B. Combinations of planes and pyramids—redistribution of segments to form new space combinations.
C. Structural pyramids.
D. Pyramidal combinations and variants as applied to ceramics.

The pyramid is a solid whose faces are triangles meeting in a common point, the *apex,* and whose base is a polygon of three or more sides. In fig. A the generator touches an eight-sided polygon.

A pyramidal surface is a surface generated by the motion of a straight line passing through a fixed point, the apex, and touching a broken line or a polygon. In fig. B the two *nappes* are shown. (A nappe is a reverse repetition of a surface.)

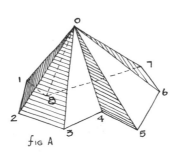

fig A

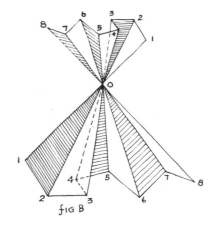

fig B

In the pyramidal sheet (fig. C), each segment is part of a triangle. The contours may be irregular curves or any combination of straight and curved lines. The line common to two adjacent segments must be a straight line.

fig C

fig D

Fig. D shows elements of three pyramids having a common base.

fig E

The *frustum* of a pyramid is produced by a cut parallel to the base. The shape of the cut or section is similar to the base. See fig. E.

fig F

The truncated pyramid is formed by a cut not parallel to the base. This produces a section different in shape from the base (fig. F).

fig G

Fig. G shows the subdivision of a pyramid by cuts parallel to elements.

fig H

A pyramidal figure produced by planes having a common element is shown in fig. H.

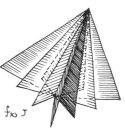

fig J

A pyramidal figure can be produced by planes passing through the axis. See fig. J.

fig K

Fig. K shows the transformation of a pyramid by means of cuts whose intersections are parallel to the base.

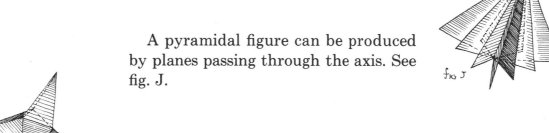

PLATE A **Open pyramidal figures using line elements and partial surfaces.**

Figure 1 is a combination of two open pyramids having a common lateral edge. The right side is composed of a single pyramid with parallel shelves, while the left is made up of five open pyramids with parallel bases.

Figure 2 is a complex figure derived from a single pyramid. In the design there are two major dominants: one vertical with intersecting sheets; the other, the horizontal base. There is a single plane of symmetry.

Figure 3. This open pyramidal structure has an interesting contrast of plane areas and lines. Emphasis is in the base, where the lines or rods meet the edges of the plane surfaces.

In Figure 4, sections are cut from a complete pyramid to produce a volume which has considerable variation in both size and shape of each face.

Figure 5 is an open figure which has a plane of symmetry passing through the apex. The general effect is of one pyramid contained within a frustum of another pyramid. The structural lines or rods add effective contrast.

Figure 6 is a structural pyramid with two triangular partial faces. The design is subdivided into two major parts: one of the triangular faces; the other, of the base rod with each of three rods meeting in the ends of the base rod.

In Figure 7, the base has been lifted to an oblique position and the support for the total figure changed.

Figure 8 is a pyramid with parallel sections. The rear upright surface is part of the basic pyramid from which this derivation was created.

Figure 9 is a structural pyramid having two dominants. Each dominant has a focal point.

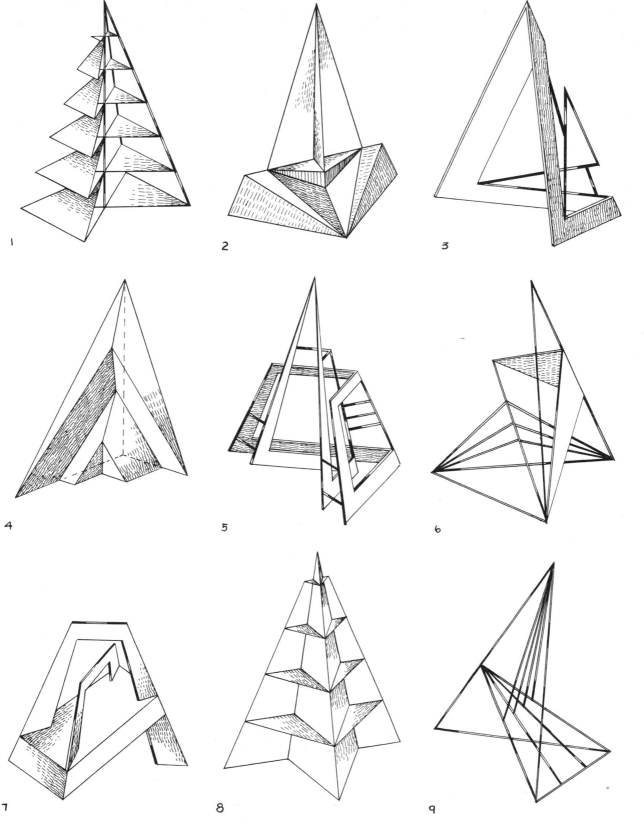

PLATE B　　　　**Combinations of planes and pyramids—redistribution of segments to form new space combinations.**

Figures 1, 2, 3, 4, 5, and 6 show combinations of total pyramidal surfaces, augmented in some of the variations by plane sheets.

Figure 7 shows a pyramid divided into three units by means of parallel cuts.

Figures 8, 9, 10, and 11 show different arrangements of the same three units. In Figure 9, a triangular prism has been added for support; in Figure 11, part of one of the units has been removed.

Redistribution of components of a basic form offer interesting and challenging problems in design. Below (figs. A and B) are two different subdivisions of the pyramid.

Create your own elements and form new volumes.

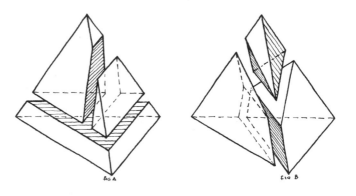

fig A　　　　　fig B

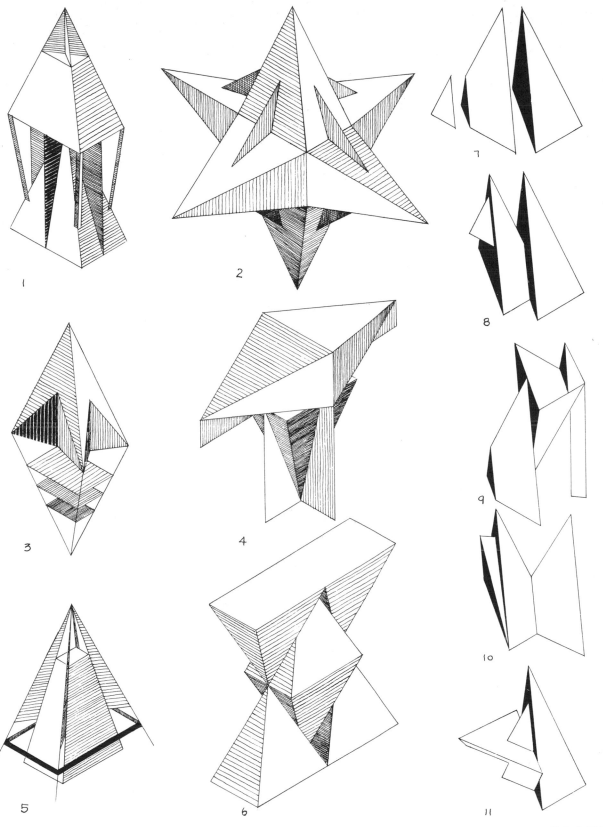

PLATE C **Structural pyramids.**

The pyramid and its application to architectural form is illustrated in the six examples of this plate.

The pyramidal volume, with its ever-ascending and converging lateral edges, adds a dramatic touch to the form that gives it a unique character and lends itself to a great variety of treatments.

In each of the six examples, there is a principal pyramidal volume. In Figure 1, a prismatic solid is combined with the pyramid. In Figure 5, a frustum of a pyramid is added to the pyramid.

The examples below (figs. A, B, C) show combinations of pyramids joined to form a single unit. (Plate B, on the preceding page, treats this problem in a different way.)

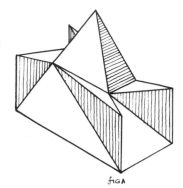

fig A

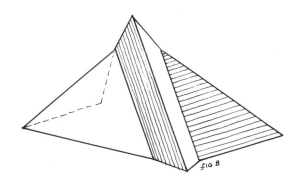

fig B

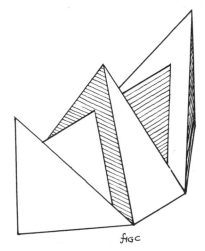

fig C

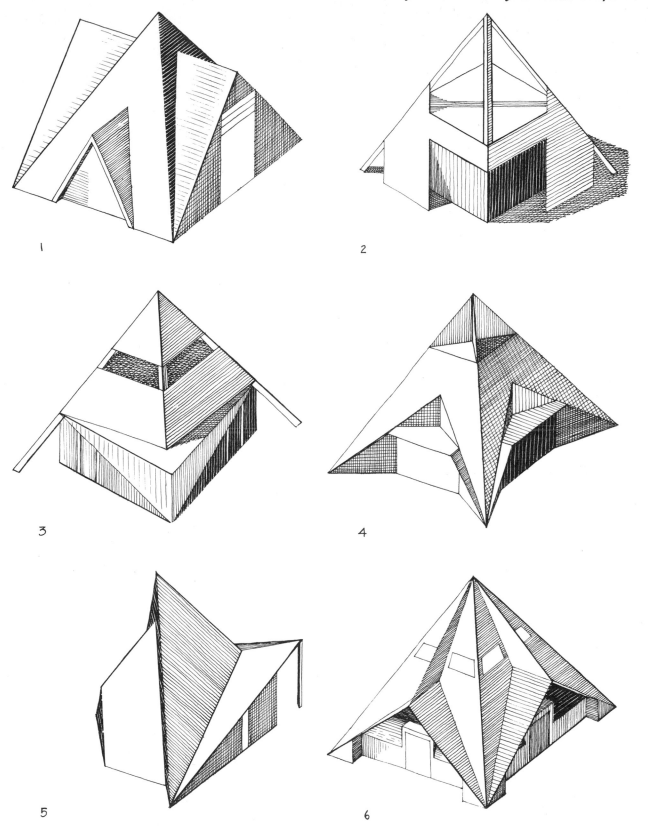

1

2

3

4

5

6

PLATE C

PLATE D **Pyramidal combinations and variants as applied to ceramics.**

The pyramid can have any number of lateral faces. With one exception, Figure 3, I have used triangular forms here. It would be a simple matter to increase the number of faces, thus increasing the possible designs enormously.

Figures 2, 5, and 15 make important use of intersecting pyramids.

Figures 1, 3, 8, 11, and 12 use parallel repetition.

Figure 13 uses repetition of form with change in both position and direction.

Note that Figures 9, 11, and 16 represent variations on a single theme.

Strictly speaking, Figure 10 is not pyramidal but conical. I have included it among the pyramids because the form was conceived with sharp edges and designed as a nine-sided pyramid. Then the edges were rounded. See fig. A, below. Incidentally, this is one illustration of the close relationship between the pyramid and the cone and of how easily one is transformed into the other.

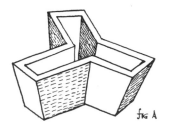

fig A

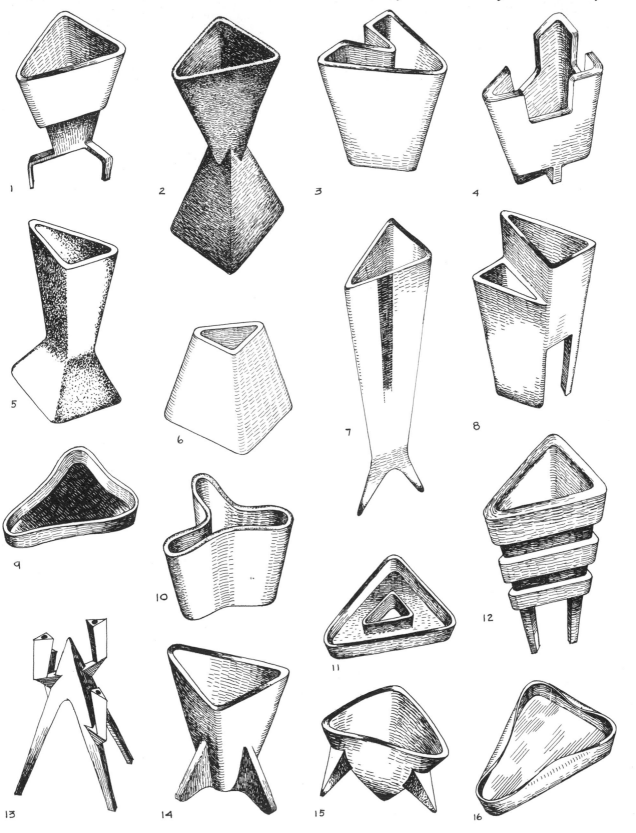

8. CONES AND CONICAL SURFACES

A. Space designs using conical surfaces in combination with connecting lines and planes.

B. Conical surface variants showing practical applications as lamp shades, light holders, receptacles.

The conical surface is formed by the motion of a straight line passing through a fixed point and touching an open or closed curve. (The fixed point must not lie in the plane of the curve.) See fig. 1, this page.

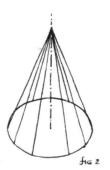

fig 1

When the closed curve is a circle, and when from the fixed point a perpendicular to the plane of the circle passes through the center of the circle, a *right* conical surface is formed. It is a surface of revolution, and each of the infinite positions of the moving line or generator makes a constant angle with the perpendicular. The perpendicular functions as the axis of rotation (fig. 2). (Study the illustrations in the section Surfaces of Revolution, page 61).

fig 2

The conical surface is a developable surface and as such can be unrolled into a plane surface without stretching or tearing or, conversely, transformed from a plane surface to a conic surface by rolling.

Figs. 3, 4, and 5 are combinations of conical surfaces.

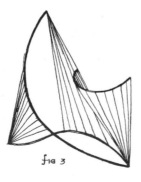

fig 3

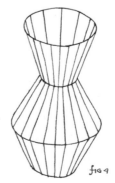

fig 4

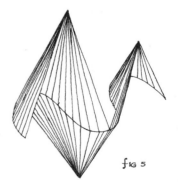

fig 5

PLATE A **Space designs using conical surfaces in combination with connecting lines and planes.**

In Figures 1, 4, and 5, only conical surfaces are used to connect various parts of the design.

In Figures 2, 3, 6, 7, and 8, there are combinations of plane and conical surfaces.

In Figure 6, one conical surface is contained within another, both having the same apex.

Figures 1, 4, and 5 in particular suggest a method for creating space designs using conical surfaces. (This method is also used in Plates B and C of the section on Sheet Surfaces, pages 77, 79, to create a variety of surfaces.)

Example

1. Start with any two curves, open or closed, not in the same plane (fig. A, below).

2. Choose a random point on each curve, and from these points draw lines touching the other curve, thus creating conic surfaces (fig. B).

3. Elaborate the design by fixing additional points on one line or both and adding the straight line elements (fig. C).

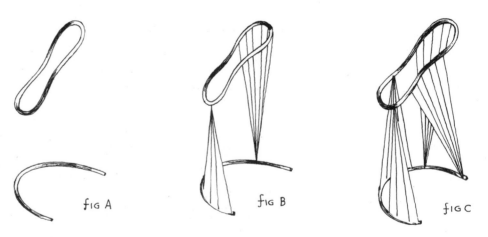

fig A fig B fig C

The character of the finished space design will depend upon the number of basic curved lines and their simplicity or complexity, and the number of points chosen as apexes of the conical surfaces. The dynamic quality of the figure will be dependent upon the tensions introduced and the feeling for equilibrium. (Except in hanging figures, which are supported from above, there is always a problem of stability and equilibrium.)

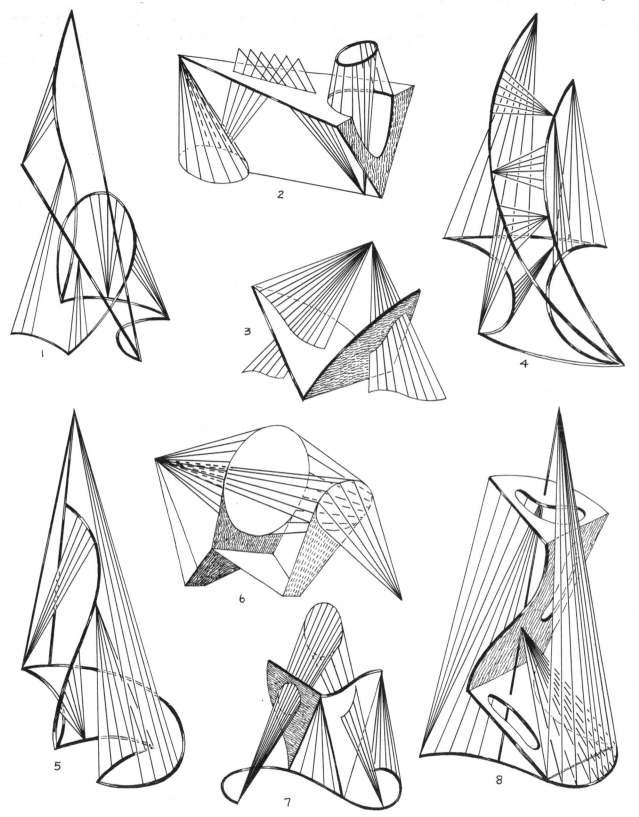

PLATE B **Conical surface variants showing practical applications as lamp shades, light holders, receptacles.**

In each of the twenty figures shown, conical surfaces are represented. In six of the variations, cones or parts of cones form the essential designs. Liberal use is made of plane figures in conjunction with the conics.

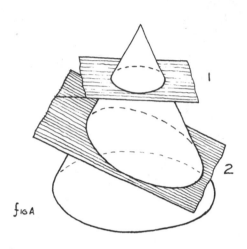

Fig A

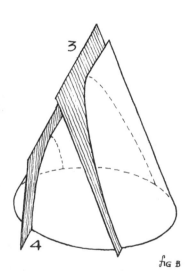

Fig B

The geometric properties of the cone are such that when intersected by cutting planes they yield a series of plane curves called the *conic sections*. The conic sections are (1) circle, (2) ellipse, (3) parabola, and (4) hyperbola.

If we take a right circular cone as our basic figure, we get the conic sections in the following way:

1. Circle—any cut parallel to base.
2. Ellipse—any cut making an angle with the base that is smaller than the angle any element of the cone makes with the base.
3. Parabola—any cut parallel to any element. This amounts to a cut making the same angle with the base that any element makes. (In a right circular cone all the elements make the same angle with the base.)
4. Hyperbola—any cut making an angle with the base that is greater than the angle that an element makes with the base.

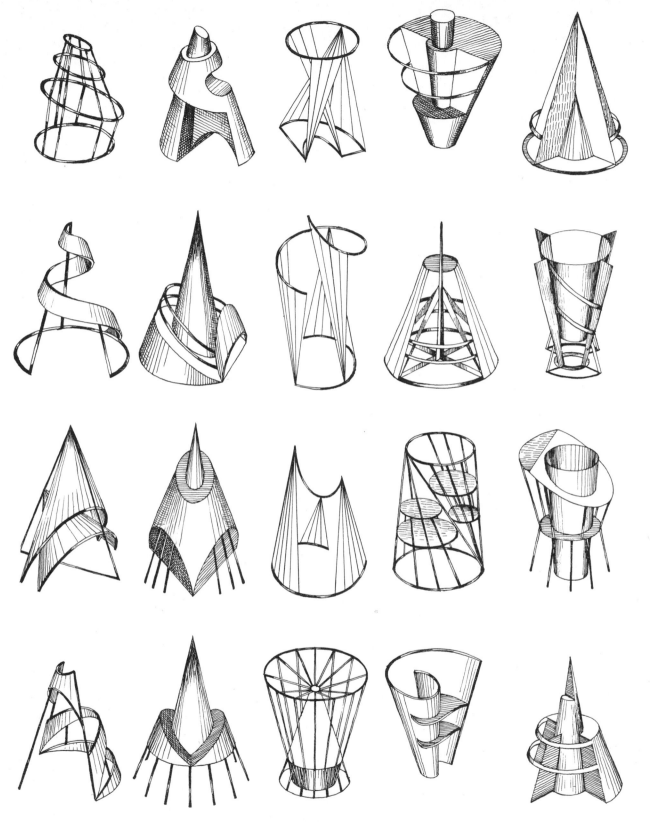

9. THE SPHERICAL SURFACE

PLATES

A. Free-form variants by pulling and pushing the spherical surface.
B. The spherical surface in combination with other surfaces to form dome-like figures.

John Ruskin once spoke of a circle as "the curve of finality." We might think of the sphere as a surface of finality. Every plane section cut from the sphere has a constant shape, varying only in size and position. If the cutting planes pass through the center of the sphere, all of the sections are *great circles* (circles having the same diameter as the sphere). The equator circle and the circles on which longitudes are measured are all great circles.

The sphere is a surface of revolution. It can be generated by the rotation of a circle using its diameter as an axis of rotation.

Spherical surfaces occur in abundance in nature, the orange or grape being two examples. The oblate and prolate ellipsoids are closely related to the sphere in shape. As the major and minor axes of the generating ellipses become more equal in length, the ellipsoidal surfaces approach the spherical surfaces in shape. When the major and minor axes of the generating ellipses become equal in length, the ellipses are transformed into circles and the resultant surfaces become true spheres.

Many parts of the human figure conform roughly to the spherical surface. Good examples are the deltoid or shoulder muscle, the buttocks, the female breast. The heads of birds, soap bubbles, and a host of other things approximate the round, ball-like shape.

Constant observation of all manner of things is necessary to the designer. He will not find perfection of form, but he will find a great variety of shapes that can be reduced to the comparatively few basic forms with which we are involved. Remember that practically every kind of mass-form that is used in the creation of a work has some modifying elements in it. The rectangular block, or the sphere, or any other geometric solid used is changed, however slightly, by the addition or removal of three-dimensional forms.

The problem for the designer has two parts: first, a study of the basic forms, their properties individually and in combination; second, a study of the modification of the basic forms by addition, removal, and distortion. A rectangular block of moist clay can be distorted by elongation or stretching, by indenta-

tion or compression. This kind of treatment is limited to material which may assume a solid or liquid state, such as clay and silver. On the other hand, wood, marble, or granite can be used by the designer only in solid blocks. This raises a question regarding the fitness of the design to the material used, certainly an important consideration. But to take an unalterable position and maintain that each material has its limitations and that therefore what is right for a design in wrought iron is wrong for the same design in clay does not take into consideration the talents, imagination, and genius of the designer whose work may refute every theory.

In the final analysis, it is the work that counts; when we impose limits that are the outgrowth of bad training, prejudices, and old wives' tales, we are simply exposing our own shortcomings.

PLATE A Free-form variants by pulling and pushing the spherical surface.

fig A

fig B

In this plate, we see how the sphere is transformed when in a plastic state by means of stretching and indenting. The general effect is that of free-form figures in which there is a continuous flow from one part to another. This leads to considerable variations in abstraction. Two or more sphere modifications may be united to obtain interesting results. See figs. A and B for example.

The sphere and its closely related solid, the ellipsoid of revolution, are free forms. The free-form surface is continuous and permits the eye to move without interruption. The transformations shown in Plate A emphasize the free-form character of the basic figure. The geometric properties of the sphere are not considered in any of the variations of this plate.

The figures are asymmetric and become combinations of partial spherical surfaces, ellipsoidal surfaces, and serpentine surfaces. Note that no partial surface generated by straight lines is used here. The use of straight-line generated surfaces, in combination with the free-form surfaces, offers interesting possibilities in the development of new forms.

As we look at Figure A, the basic sphere, we realize that all parts of it are of equal importance. Considered as a design figure, it has no contrast, no tension, no emphatic interest. When we compare it with any of the nine derivatives, we see that the elements missing in the sphere create interest in the new figures.

Figures 1 and 2 retain in part the feeling of the spherical surface, although the over-all geometric shape has been completely changed.

Figures 3 and 4, which introduce open spaces, depart almost completely from the basic figure although some of the smaller components are spherical.

Figures 5, 6, 7, 8, and 9 add a considerable amount of tension to the general designs by dividing each figure into dominant volumes.

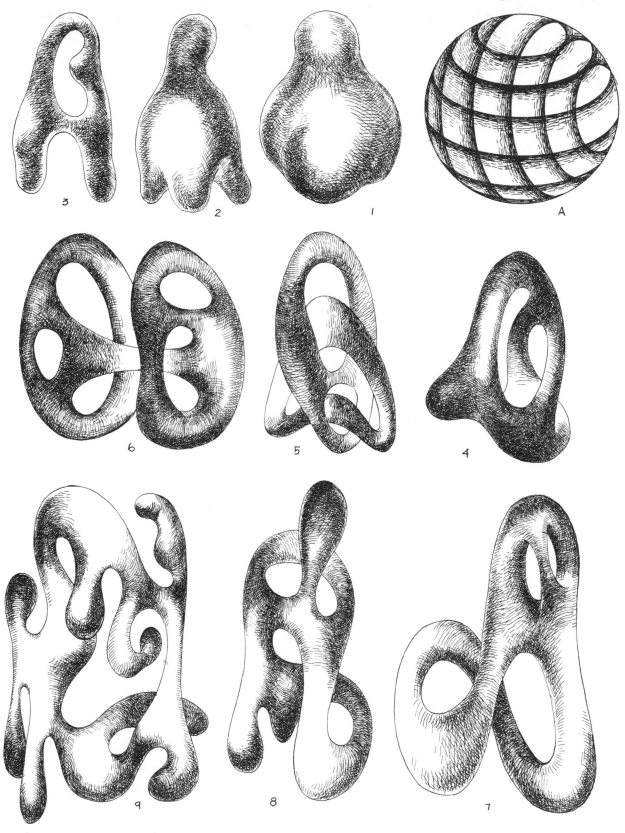

PLATE B The spherical surface in combination with other surfaces to form dome-like figures.

When a plane cuts a spherical surface, the section cut is a circle. A partial cut produces the arc of a circle.

Figures 1 and 3 show combinations of spherical and plane surfaces with circular arcs as the lines of intersection.

Figure 6 shows a helicoidal surface forming a pathway on the sphere. The connecting lines form conical surfaces.

Figures 4 and 12 use the plane surface and the hyperbolic paraboloid surface (warped quadrilateral).

Figures 7, 9, and 10 show space curves of the open spherical surfaces. (The circle is the only plane curve that can be drawn on the surface of the sphere.)

Figures 5, 8, and 11 show combinations of plane and spherical surfaces. In Figure 11 the three parallel round wires form the spherical surface.

Figure 2 shows two spheres united by a twisted round wire.

Figure 7 shows a combination of cylindric and open spherical surfaces.

Other surfaces can also be combined with the spherical surface. Figs. 1 and 2, below, show how conic, plane, and cylindric surfaces are combined with the sphere.

fig 1

fig 2

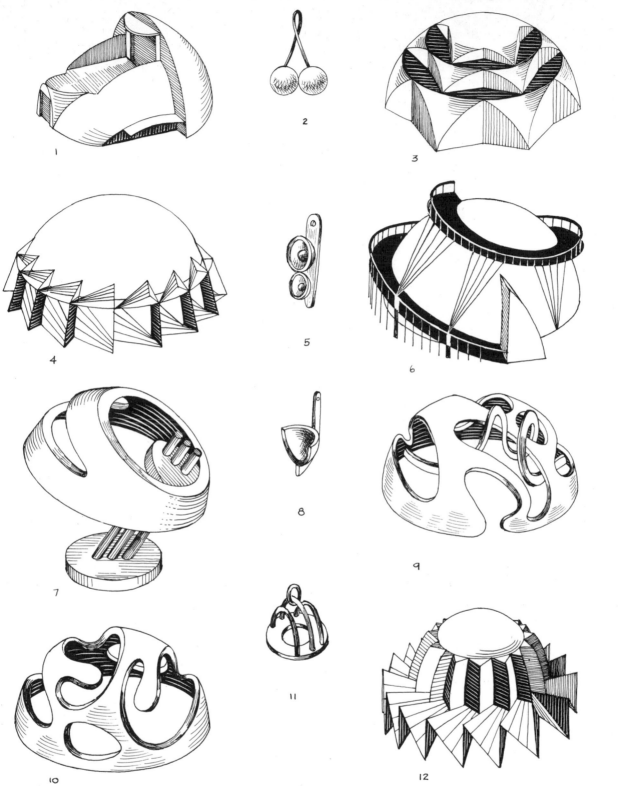

10. SURFACES OF REVOLUTION

PLATE

A. Meridian sections of surfaces of revolution. The generating line may be all straight, all curved, or a combination of the two.

A surface of revolution is a surface generated by the rotation of a line about an axis, the line and axis lying in the same plane. The moving line may be curved, straight, or a combination of both. As the moving line or generator rotates about the axis, every point in the moving line describes a circle, and the plane of the circle is perpendicular to the axis. See fig. A. Line 1–2–3–4 is the moving line or generator. The circular path of each point is also shown.

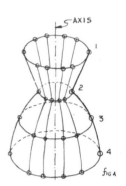

The total surface is composed of an infinite number of circles, each circle being the path of one of the infinite points on the generator. This is a unique feature which makes it possible to shape such a surface on a lathe or a potter's wheel.

A wood-turner places a rectangular block of wood in a lathe, and as the wood rotates, a cutting tool is applied which shapes the block, thus producing the leg of a chair. The complete surface may be a composite of two or more of the surfaces illustrated in Plate A. The lathe may also be used to raise a surface of revolution by a process called spinning. Generally a flat circular sheet of aluminum is placed in a lathe pressed against a chuck. As the aluminum sheet rotates, a tool is pressed against the metal, forming it into a shape which fits snugly around the chuck. Many types of metal lampshades and automobile headlights are made by this spinning method.

The most common types of surfaces of revolution are illustrated below.

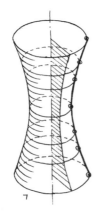

1. *Right circular cone.* The straight line generator makes a constant angle with the axis. (The generator may or may not touch the axis.)

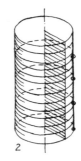

2. *Right circular cylinder.* The straight line generator is parallel to the axis.

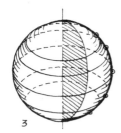

3. *Sphere.* The diameter of the semicircle generator coincides with the axis.

4. *The prolate ellipsoid.* The major axis of the semiellipse generator coincides with the axis.

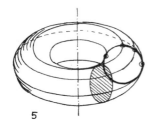

5. *Annular torus.* A circle is the generator.

6. *General torus.* A compound open curve is the generator.

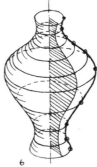

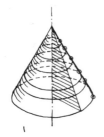

7. *Hypoid.* A hyperbolic curve is the generator.

PLATE A **Meridian section of surfaces of revolution. The generating line may be all straight, all curved, or a combination of the two.**

In this plate, each of the variations shows the outline of the template which produces a surface of revolution as it is rotated. The straight-line parts of the template form conical and cylindrical surfaces while the curved lines form toroidal surfaces.

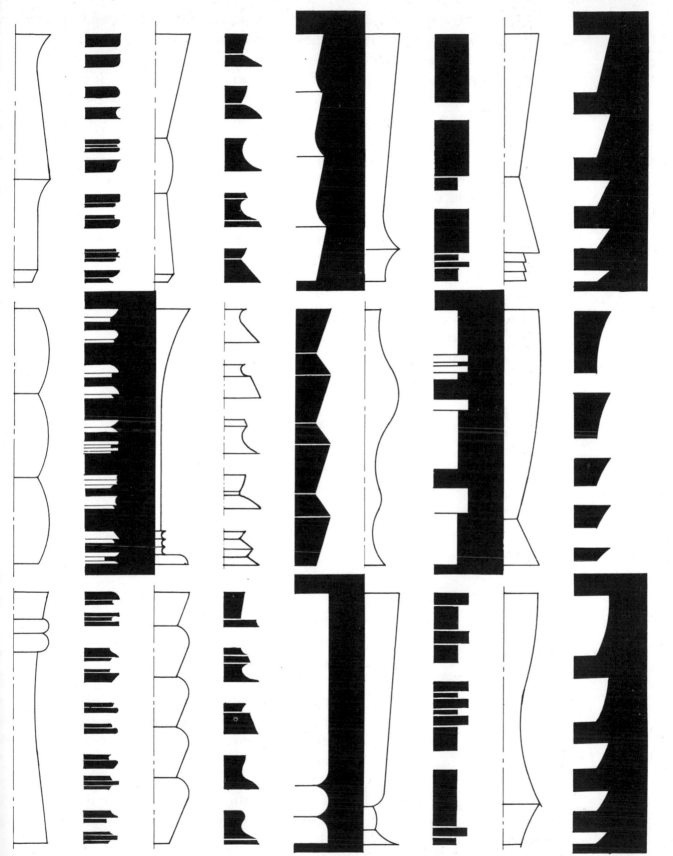

11. THE RIBBON SURFACE

The term "ribbon surface" refers mainly to plane, cylindric, and helicoid surfaces. These surfaces are characterized by their comparative thinness and a general feeling of airiness and grace. Fantastic space figures may be created by combining ribbon surfaces. The resultant open-type forms very often have a delicate quality without sacrificing a feeling for structural soundness.

Start with a very thin elongated rectangular prism. All the faces are plane surfaces.

Convert it to cylindric. Figs. B and C show coils wound around a cylinder. In fig. D, the coil is wound around a cone.

In figs. A, B, C, and D there is no stretching or tearing of any part of the original to form the new surfaces.

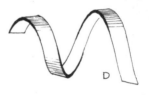

A

B

C

D

These figures show formations of various types of surfaces by twisting.

fig 1

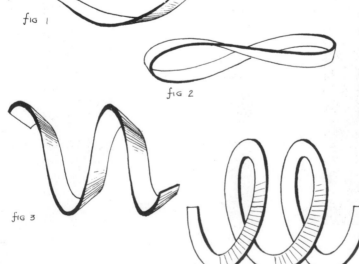

fig 2

fig 3

fig 4

The moebus surface: to obtain the moebus surface, first give the ribbon one twist (fig. 1). Then turn both ends until they meet, retaining the twist (fig. 2). A unique feature of this surface is its continuity. A continuous closed line may be drawn which will lie on both the outside and inside surfaces without crossing an edge.

The oblique helicoid is shown in fig. 3. The right helicoid is shown in fig. 4.

The term "ribbon surface" describes only in the most general way the character of this surface. There is no measure by which we can determine the exact dimension of thickness. It is only our own sensitivity and awareness that help decide for us in which category to place the surface.

The geometric properties of a surface have nothing to do with our reactions to the surface nor our preferences in employing one as against another in design. The choices we make in the use of basic forms point up not the differences in the basic forms, so much as the differences in ourselves. What we regard as suitable to our purpose one day may not be to our liking the next. Throughout all of the variations in treatment of the materials of design, there exists for each individual what may be called the least common denominator. It is the residue, the precipitate or that mysterious something which gives individuality to the work and sets it apart, in some degree, however slight, from the work of every other designer.

Figs. 5, 6, and 7, show forms made from the ribbon surface.

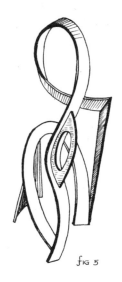

fig 5

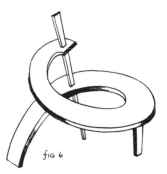

fig 6

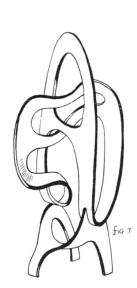

fig 7

12. STEPPING OUT OF THE PLANE

PLATES

A. Plane surfaces with varying contours bent into space transformations. Several examples show parts of the plane converted into cylindric surfaces.
B. Extension of planes into space figures through combination with other planes and cylindric surfaces.
C. Projection of lines and surfaces into space to unite with plane, creating space figures. Especially conceived for jewelry design.

The plane surface is the simplest of all surfaces and the most common in our daily contacts. The theoretical concept of a plane surface is important to us because we can picture the multitude of lines, straight and curved, which compose the plane. Lift any part of the plane, or a single line from it, and the combination of the plane and the single line out of the plane becomes a space or three-dimensional figure. In fact, all we need to do is take a single point from the plane to produce a space magnitude. That is, the plane and the point now lying outside the plane fulfill the requirements for a three-dimensional object.

Of course, when we speak of "taking a point out of a plane," we are assuming a feat of magic which excites the imagination, but which cannot be achieved with actual tangible objects. Think of the point out of a plane as being the intersection between all the lateral edges of a pyramid. This point, or apex, becomes a real thing to us because we can construct a pyramid. Picture the pyramid with its pentagonal base resting on a table and the apex three inches from the base. Now quickly remove the lateral faces, leaving only the five-sided base and the apex. We are left with the same combination of a plane and a point lifted out of it.

If we extend this lifting process, we can now use areas and, by extension, convert the plane surface into a great variety of space figures.

PLATE A **Plane surfaces with varying contours bent into space transformations. Several examples show parts of the plane converted into cylindric surfaces.**

Figures 5, 7, 10, and 11 are the ones in which parts of the plane surface were converted into cylindrics.

Figures 3, 4, 8, 9, and 10, although they are very simple, bring to mind the human form.

In Figures 2 and 7, twisted surfaces derived from narrow strips of the plane surface are used as connections between dominant parts of the designs.

"Stepping out of the plane" involves a special kind of thinking. When a sculptor starts with a block of wood or granite, he evolves his shapes by reduction or subtraction. He removes volumes to arrive at the ultimate figure. The sculptor who begins with the stepping-out-of-the-plane concept gets his results by the *addition* of volumes. The modern sculptor is beginning to use this process and way of thinking more and more in his design. Until quite recently, it was the almost exclusive province of the metal craftsmen who created their space figures from sheets of metal which correspond to the plane surface.

Many helpful exercises in space design can be practiced with paper, a pair of shears, and imaginative folding.

1. Start with simple contours, such as the rectangle, triangle, or diamond-shape quadrilateral.

2. Create irregular shapes, all straight lines.

3. Create curved contours and internal cut-outs.

4. Combine curved and straight contours with internal cut-outs and connecting surfaces, straight, cylindric, and twisting.

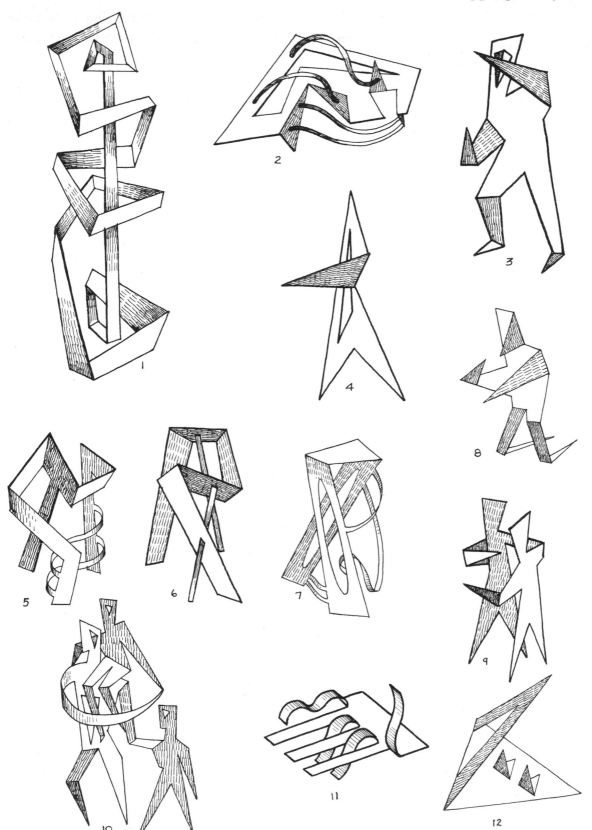

PLATE B **Extension of planes into space figures through combination with other planes and cylindric surfaces.**

In this plate, we see an extension of the method suggested in Plate A, in that each design may be considered a combination of two or more independent surfaces attached to one another, rather than a design derived from a single basic plane surface.

The conversion of a plane surface into a cylindric surface is easily imagined, so we can say that all the variations using cylindrics are derived from the plane surface. In actual practice —particularly if the objects in this plate were to be made of metal—each component part would be stamped out of a large plane sheet. Dies would be used to shape the various parts, and then the parts would be fastened by soldering.

The thirty-six examples in this plate may be divided into the following:
1. All plane surfaces; straight-line contours.
2. All plane surfaces; straight-line and curved-line contours.
3. Combination of plane and cylindric surfaces.

Note the difference in effect of the designs in the three major divisions. How many of the figures can be made from a single plane shape?

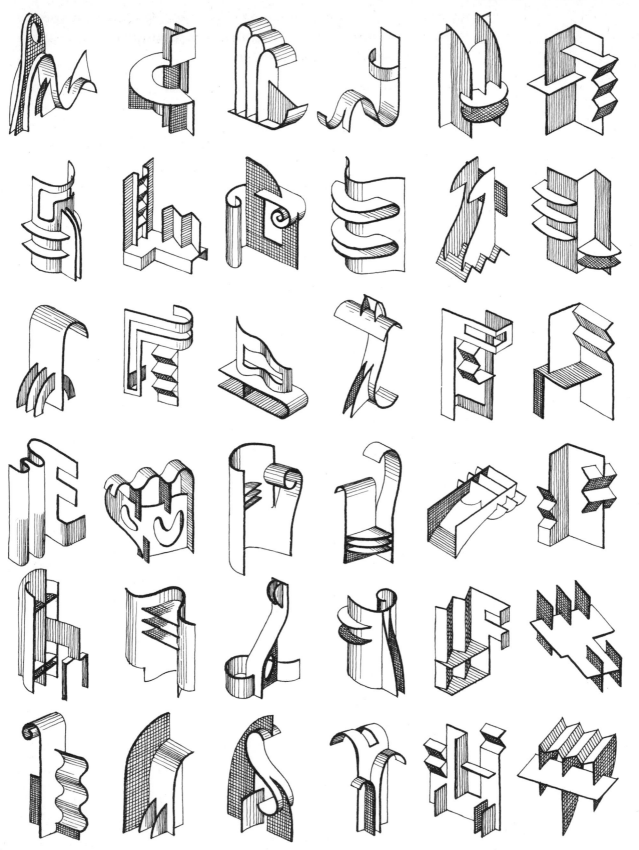

PLATE C **Projection of lines and surfaces into space to unite with plane, creating space figures. Especially conceived for jewelry design.**

In the fifteen examples shown here, designed expressly for execution in silver, the additive process is used to create each space figure. The basic contours for the most part are irregular.

The wire used in Figures 2, 4, 8, 12, 14, and 15 represent a departure from the examples shown in Plates A and B, in that the wire forms are derived from cylindric surfaces, not plane surfaces.

In Figure 3, the four transition bars give the effect of an inclined surface.

By changing relative proportions, we can create space figures quite abstract in feeling and having a genuine sculptural quality. The examples below (figs. 1, 2, 3) illustrate this.

fig 1

fig 2

fig 3

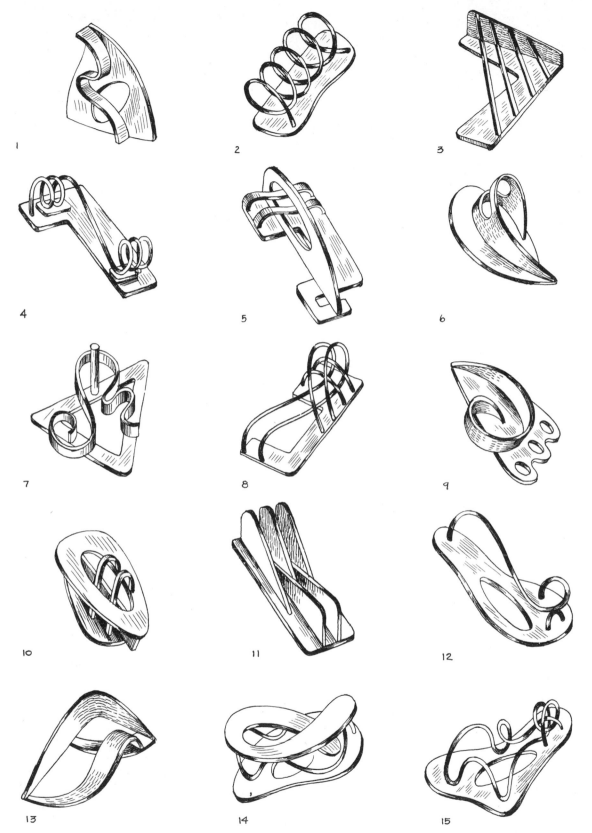

PLATE C

13. THE SHEET SURFACE

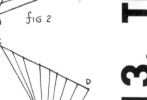

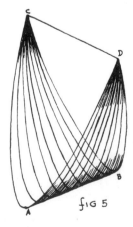

fig 1

fig 2

fig 3

fig 4

fig 5

PLATES

A. Sheet surfaces showing linear elements and various connecting lines.
B. Surfaces determined by curved lines.
C. Connecting lines and surfaces suggested by the curved lines.

The ribbon surface, as we have seen, is a narrow band. The sheet surface begins where the ribbon surface leaves off. We need not worry about fine distinctions. It is more important to develop an awareness of the essential difference. Broadly speaking, the difference is one of extension, in which the ribbon surface may be as *narrow* as we wish it to be and the sheet surface has no limit in *width*.

The plane surface is the simplest of all sheet surfaces. Next in order of difficulty are the developable surfaces: the prismatic, pyramid, cylindric, conic, and convolute. The convolute in this group is the most difficult to visualize and use because it is not an easy matter to determine the elements that make it up.

The non-developable sheet surfaces include the spheric, toroid, ellipsoid, conoid, and hyperbolic paraboloid. Just as a very small arc of any curve may be regarded as the arc of a circle, a very small section of a non-developable sheet may be regarded as the surface of a sphere.

Think of the sheet surface as a cover extending between limits imposed by the designer. The cover may be a continuous surface or it may be made up of combinations, as shown in figs. 1, 2, 3, 4, and 5, this page. In each of these five illustrations, two straight lines, AB and CD, are united by means of sheet surfaces.

In Plate A, facing page, and in Plates B & C which follow, we see the elements or skeletons of the sheet surfaces that have been created to unite various combinations of straight and straight, curved and curved, and straight and curved lines.

PLATE A **Sheet surfaces showing linear elements and various connecting lines.**

1

2

3

4

5

6

PLATE A

PLATE B **Surfaces determined by curved lines.**

The basic problem illustrated in the twelve Figures of this plate is one of creating surfaces that will connect more lines. The lines may be all straight, all curved, or combinations of straight and curved.

The designs as shown are open, revealing the skeletal structure. We can easily imagine stretching parchment or cloth to form smooth-flowing sheet surfaces to cover the skeleton.

In each of the examples, the lines have been arranged so that parts would remain open after sheet surfaces had been applied. The combination of open and closed areas and volumes adds a lively interest to the design as a whole.

As a rule, when we start with a group of lines not in the same plane, the various surfaces that result are an outgrowth of the types of lines that are used; in this way, interesting combinations can be created that would be almost impossible to conceive in any other way. In the introductory remarks and illustrations for this group of plates, only two basic straight lines were used, united by different connecting surfaces. In the examples below (figs. 1, 2, 3), the number of basic lines has been increased to three and four.

1. One group (fig. 1) is all straight lines.
2. One group (fig. 2) is all curved lines.
3. One group (fig. 3) is straight and curved lines.

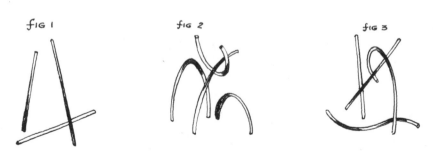

A space model can be made from such combinations when a sufficient number of lines are used. Gauze may be stretched over the lines and then plaster of paris applied over the gauze. (The shell of plaster of paris should be thick enough to allow for smoothing.)

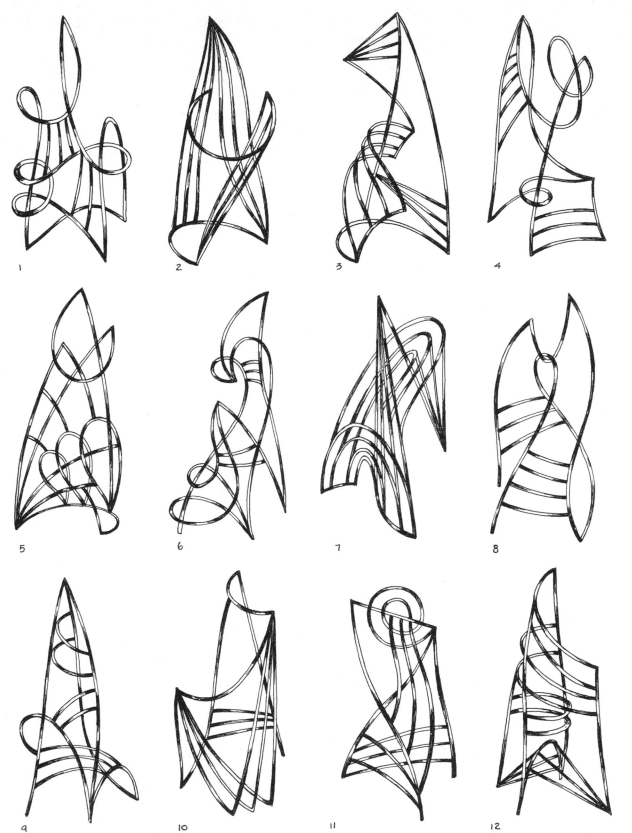

1

2

3

4

5

6

7

8

9

10

11

12

PLATE B

PLATE C **Connecting lines and surfaces suggested by the curved lines.**

An extension of the problem of connecting lines by means of surfaces is presented by using closed figures as the basic lines.

Figure 2 shows two elliptical lines as basic to the design. (Figure 4 in Plate A uses a triangle and two circles.)

The basic closed lines are:

fig 1

1. All curved (fig. 1, right).

fig 2

2. All straight, perhaps with rounded corners (fig. 2, left).

fig 3

3. Combined straight and curved (fig. 3, right).

fig 4

4. Space closed curves (fig. 4, left).

Figs. 1, 2, and 3 are plane curves; fig. 4 shows space curves.

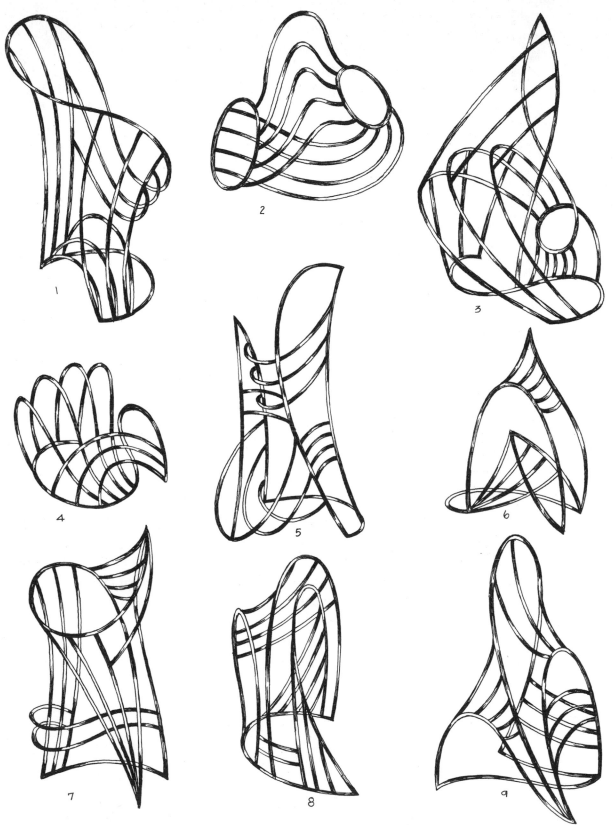

PLATE C

14. COMBINATIONS OF SURFACES AND SOLIDS

PLATES

A. Intersections between cylinders, prisms, and pyramids.
B. Various treatments of the candelabra.
C. Architectural forms showing combinations of surfaces that include the hyperbolic paraboloid and the helicoid.
D. Ceramic receptacles showing variety of body shapes, handles, and bases.
E. Variations in the treatment of table legs.

PLATE A Intersections between cylinders, prisms, and pyramids.

Each variation in this plate is essentially architectural in feeling, although it was not my original intention to suggest building forms. The designs are part of a large series in which interest lies in the effect that neighboring surfaces have on each other in combination. The changes in direction, the changes in surface characteristics, the lines of intersection within the extreme contours, offer much material for study.

This type of exercise comes under the heading of pure research. It has a fascination all its own, but the more important effect is to give to the designer a greater awareness of his design tools, to widen his experience and develop his sensitivity.

Keep the following possibilities in mind when making studies in the combination of surfaces:

1. Change in size.
2. Change in shape. (Only in the regular solids and the sphere do the shapes remain the same, regardless of size.)
3. Change in the direction of the solid as a whole and of the individual faces.
4. Change in dominant form.
5. Repetition of component forms in part or in their entirety.

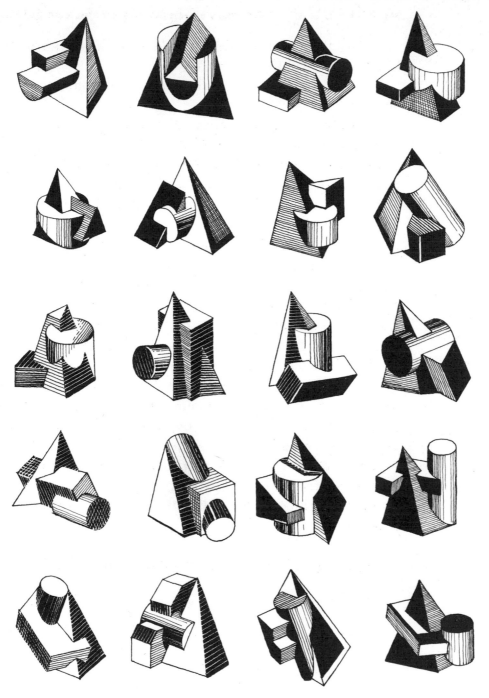

PLATE A

PLATE B **Various treatments of the candelabra.**

Figure 1 is a combination of thin, rod-like cylindrics and hollow cylindric tubing.

Figure 2 is a combination of conical, prismatic, and cylindric surfaces.

Figure 3 is a combination of conical and cylindric surfaces with uniting plane surface sheets.

Figure 4 is a combination of hypoid and cylindric surfaces with parallel conical surfaces as the base.

Figure 5 is a combination of prismatic and conical surfaces with bent cylindric rods.

Figure 6 is a combination of prismatic and cylindric surfaces wth bent cylindric rods.

Figure 7 is a combination of cylindric surfaces with pyramidal holders.

Figure 8 is a combination of prismatic surfaces with circular discs and hollow cylindric candle holders.

Figure 9 is a combination of prismatic and cylindric surfaces.

Until you are certain that you know what the fundamental surfaces are, how they are generated, and what some of their properties are, go back and study further the plates and text on the fundamental forms.

The contour or outline of a surface does not determine the kind of surface it is. The examples at left (figs. 1, 2, 3) are all cylindric surfaces, although their extreme contours vary considerably.

fig 1

fig 2

fig 3

Figs. 4, 5, 6, 7, 8, below, are all conical surfaces.

fig 4 fig 5 fig 7 fig 8

fig 6

The examples in figs. 9 and 10 are prismatic surfaces.

fig 9

fig 10

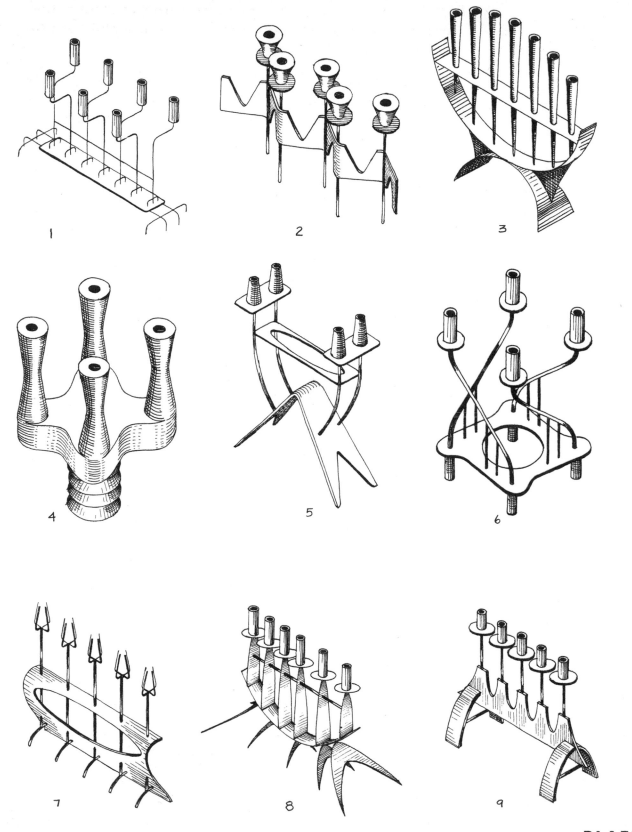

PLATE C **Architectural forms showing combinations of surfaces that include the hyperbolic paraboloid and the helicoid.**

Figure 1 is a combination of cylindric, conical, and prismatic surfaces. The dominant surfaces are prismatic. The contrast makes the conical surface, in particular, more striking.

Figure 2 combines plane surfaces and cylindrics, with the cylindrics dominant.

Figure 3 is helicoidal, cylindric, and prismatic surfaces combined. The helicoidal surface helps unite the two vertical prismatic volumes.

Figure 4 uses pyramidal surfaces, and is an example of the repetition of similar and related parts.

Figure 5. Plane surfaces, prismatics, and warped quadrilateral or hyperbolic paraboloids make up this variation.

Figure 6 is made up of dominant conical surfaces with vertical prisms.

In Figure 7, dominant cylindrics are united by prisms. The central form is conical and is the chief interest in the design.

Figure 8 uses plane surfaces and prismatics with important conical surfaces.

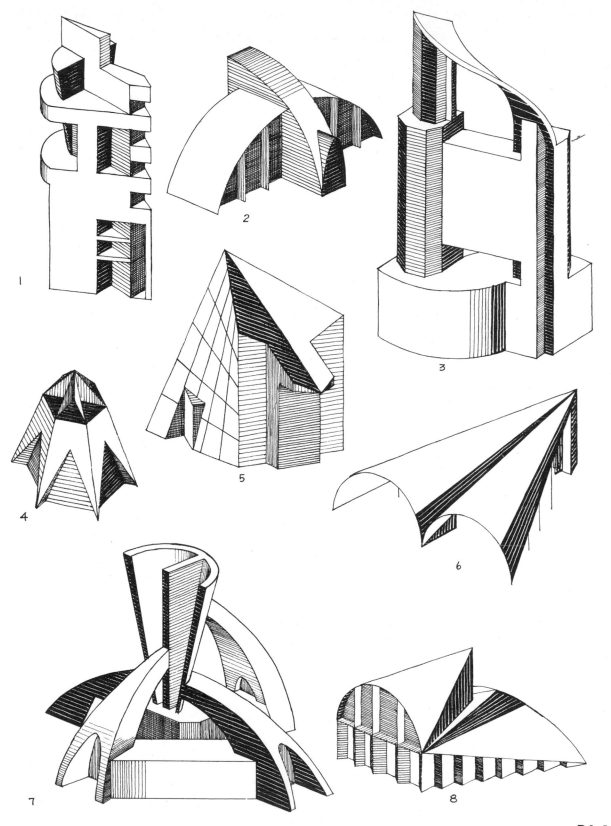

PLATE C

PLATE D **Ceramic receptacles showing variety of body shapes, handles, and bases.**

Many types of surfaces are represented in the thirty-six bowls in this plate. Only one surface of revolution is shown, and it is the only one that can be turned on a wheel. Most of the surfaces are toroidal and ellipsoidal.

In studying combinations of surfaces, it is well to keep matters under control by using one basic surface and adding variations to it in changing proportions.

1. Let's start with a basic ellipsoidal surface (fig. 1).

2. Keeping the top and bottom sections constant, change the central portion, making each figure a surface of revolution (figs. 2–9, below).

fig 2 fig 3 fig 4 fig 5 fig 6 fig 7

3. Keeping top and bottom sections constant as in #2, convert into a series of shapes which cannot be turned on a wheel (figs. 10–13, below).

4. Using a portion of a basic surface in combination with other surfaces, create shapes which are (a) all conic (if the basic surface is conical); (b) conic and plane; (c) conic and cylindric; (d) conic and toroidal.

fig 8 fig 9

 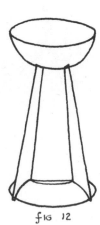 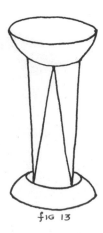

fig 10 fig 11 fig 12 fig 13

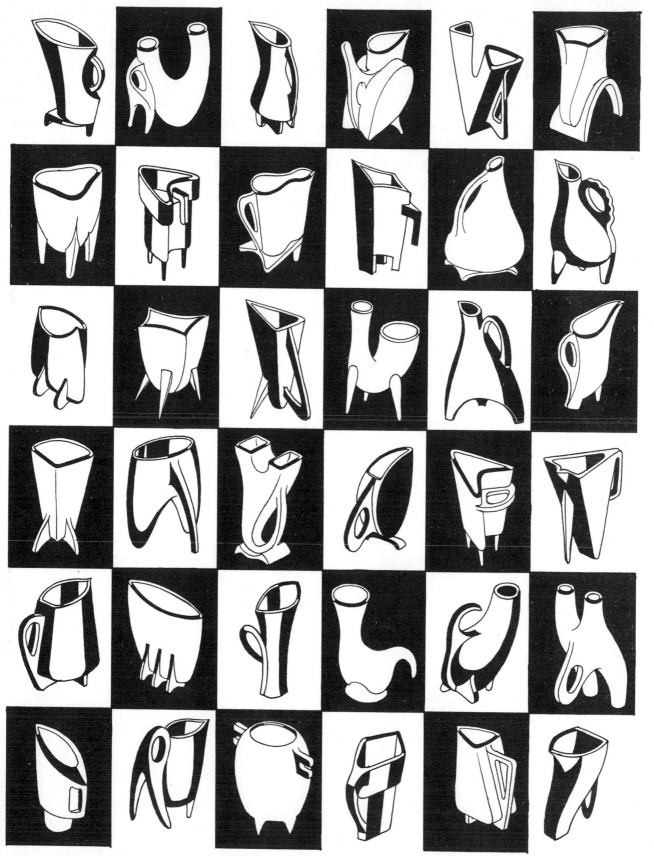

PLATE E **Variations in the treatment of table legs.**

All of the table tops are round-cornered triangular prisms, made to look transparent in order to show the design of the supports. It is very difficult to generalize about the supports and say that they should be one thing or another, but I think that we can agree that (1) the support must give a sense of equilibrium; and (2) the support must not be over-dominant. Its function, important as it may be, is secondary to the table top.

Ease of manufacture and assembly are vitally important when the economic phase of design has to be considered. Every practicing designer knows this only too well. It is a subject which lies beyond the scope of this book. Still it is worth mentioning because I believe that every creator in three dimensions should ask himself, "How is this going to be made?"

The designer with a background of wide experience does not have to think about construction consciously, because his training and repeated experience have made it a part of his thinking. The student, without the necessary experience, cannot successfully cope with construction problems and at the same time do the actual designing. It is suggested here that it is advisable, from time to time, to leave the realm of theory and consider the practical construction problems involved.

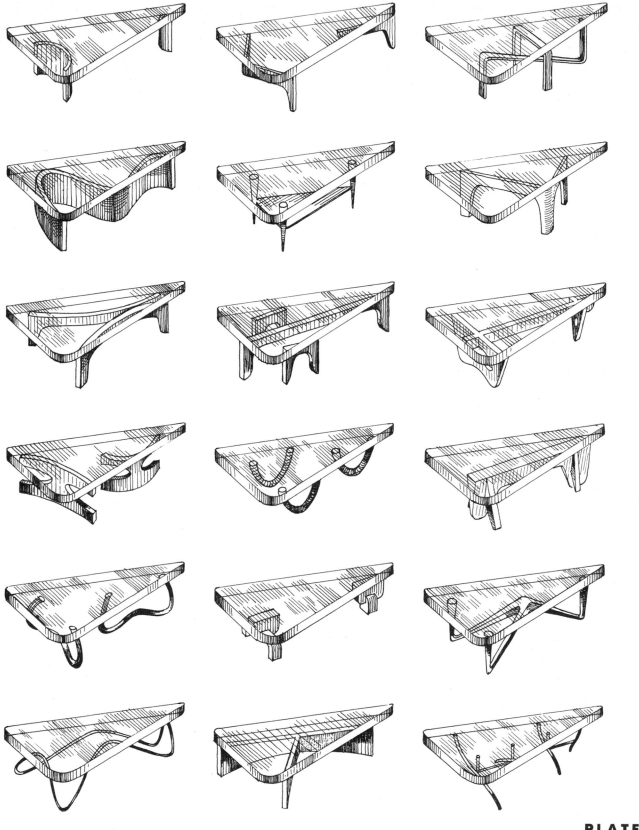

PLATE E

15. SPACE CURVES

A space curve is a curve in which every possible combination of three successive points does not lie in the same plane.

A plane curve is in its entirety part of an infinite plane surface while a space curve cannot in its entirety lie wholly within a plane surface. A space curve can never project as a straight line on a plane surface. To put it another way, the representation of a space curve must be a curved line.

In most instances the lines of intersection between the basic surfaces are space curves. Two interesting exceptions are: 1. Two equal right circular cylinders whose axes intersect; 2. Two right cones with common internally tangent sphere. In each case the intersections are two ellipses crossing each other. The ellipse is a plane curve.

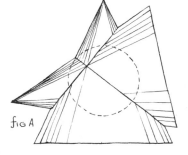

Figures A and B represent views on a plane parallel to the axes of the respective cylinders and cones.

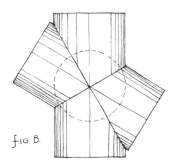

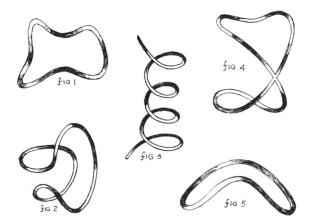

1. Intersection between two cones.

2. Line on a sphere.

3. Coil around hypoid.

4. Intersection between two cylinders.

5. Intersection between two cones.

16. DESIGN OF TABLE TOPS

PLATE

A. The square top and variants.

In the Plate which accompanies this section (page 95), the basic shape used is a square. By keeping one side of the square fixed and changing the length of the adjacent side, we can get any number of variations (see fig. B, below, for one example). In figs. A and C, the surfaces are the same shape but not the same size; the ratio of the length to the width is the same in both rectangles.

The age-old problem of determining the best, or aesthetically most pleasing, shape has not been solved to my knowledge, notwithstanding some of the claims made by proponents of "dynamic symmetry." Any design in which the ratios of the sides of the various parts are related to each other produces an harmonious effect. A kind of unity is achieved in which the parts vary only in size and direction.

In a sense, this is the safest kind of design to use, if not necessarily the most exciting or stimulating. One of the drawbacks is the monotony which comes from constant repetition.

In some types of contemporary design, the term *module* has been used to characterize repetition of ratios. It has been widely exploited, particularly in architectural and furniture design, but it is nothing new. The Greeks not only did it but had a word for it. The ratios change; that is all.

We might start with a circle as the basic shape. Note how the circle and square are related (fig. 1). The two diameters of the circle are the same length as the two bisectors of the sides of the square.

Suppose that we arbitrarily choose a rectangle as the basic shape (fig. 2). The curved figure bearing the closest relationship to it is the ellipse whose axes have the same ratio as the sides of the rectangle (fig. 3).

Think of the square and the circle as being related.

Think of the rectangle and the ellipse as being related.

Think of the cube (fig. 4) and the sphere (fig. 5) as being related.

Think of the rectangular prism (fig. 6) and the ellipsoid (fig. 7) as being related. (The ellipsoid is not a surface revolution.)

PLATE A **The square top and variants.**

If we confine ourselves to the plane figures which represent the top views of solids, we have the square, the rectangle, the circle, and the ellipse. This Plate illustrates variations of the square. In each drawing, only the top view is shown. Thickness, the third dimension, is not illustrated.

Of the twenty variations, 5 are all straight lines, 7 are all curved lines, and 8 are combinations of straight and curved lines.

Figs. 8, 9, and 10, below, illustrate variations of the circle: all curved lines (fig. 8), all straight lines (fig. 9), and a combination of straight and curved lines (fig. 10).

Of the variations of the rectangle (figs. A, B, C), fig. A is all straight lines, fig. B is all curved lines, and fig. C is a combination.

Variations of the ellipse are shown in figs. D, E, and F. Fig. D is all curved lines, fig. E is all straight lines, and fig. F is a combination.

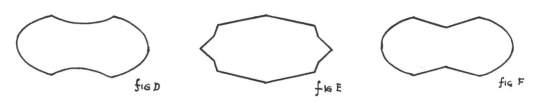

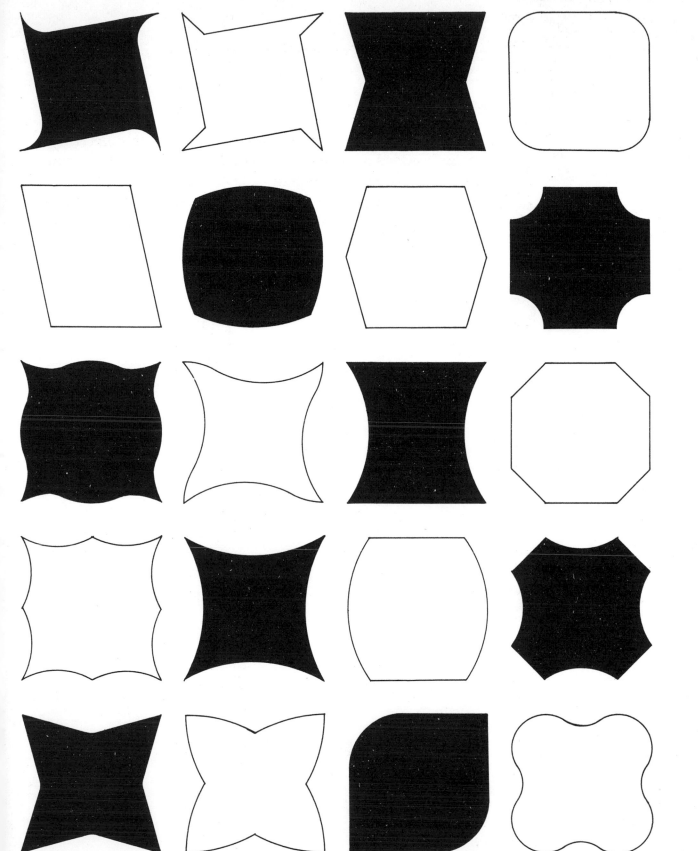

17. ANGULAR TRANSFORMATION OF TREE FORM

PLATE

A. Space effect heightened by sharp changes in the direction of various parts.

PLATE A

Change in direction adds a sense of motion to a design. If to this is added a change in shape, the possibility of creating new forms is greatly increased.

The examples below (figs. 1–4) show both changes in direction and changes of shape. The basic volume is derived from the same general tree form used in Plate A.

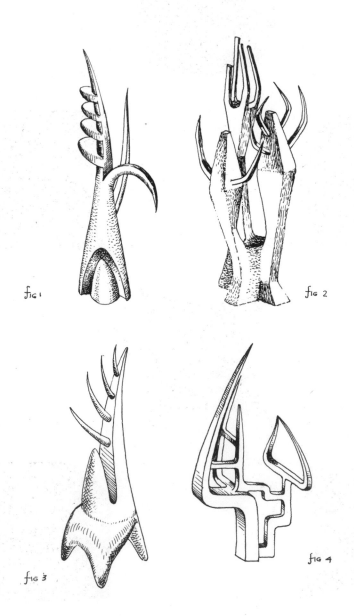

fig 1

fig 2

fig 3

fig 4

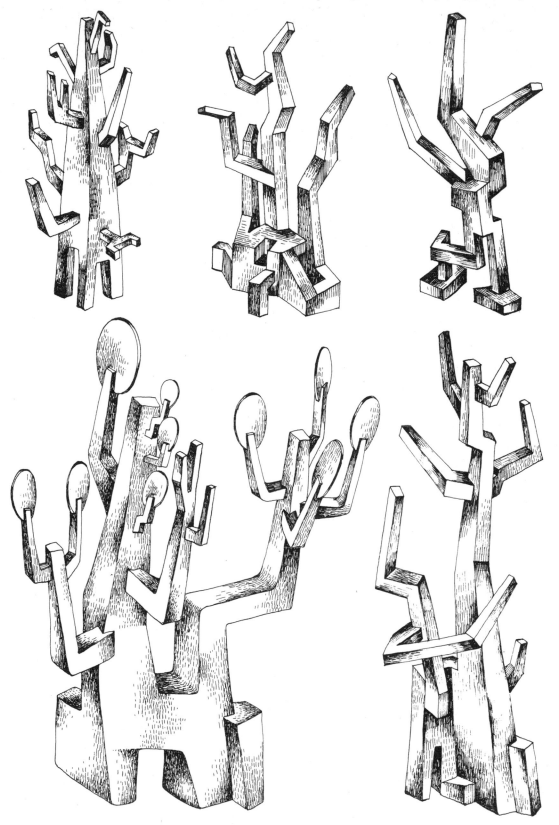

18. THE PLANE AND ITS SPACE EQUIVALENTS

PLATES

A. Space interpretation in which two of the curved surfaces are non-developable (Variations #1 and #2).

B. Plane, cylindric, and conic surface variants of four plans.

C. A front elevation and its space interpretations, using plane and cylindric surfaces only.

1. Begin with a rectangular block (fig. 1).

2. If we wish to represent the block on a sheet of paper, the paper becomes the plane of reference (fig. 2).

3. The simplest position of the block and plane of reference in relation to one another is that position in which the greatest number of faces of the block are parallel to the plane of reference (fig. 3). (In this discussion it does not matter whether the plane of reference is below or above the rectangular block.)

4. I have chosen the position in which the block is above the plane of reference. Theoretically, the plane of reference is infinite in extent. The sheet of paper on which the representation or drawing of the block is made is but a convenient, finite, workable size.

fig 1

fig 2

fig 3

5. If from each point on each surface of the block, perpendiculars are drawn to the plane of reference, each of the perpendiculars will touch the plane of reference in one and only one point. The point (pierce point, foot of perpendicular) on the plane of reference is a projection or representation of at least one point on the surface of the block. The total representation or projection is in effect the sum of all the points in which all of the perpendiculars from each and every point on the surface of the object meets or touches or pierces or intersects the plane of reference (fig. 4).

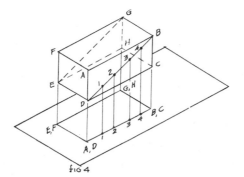

fig 4

We can now make the following generalizations based on a careful study of fig. 4:

If a line is parallel to a reference plane, the representation or projection will be equal in length to the line itself. (Line AB.)

If a line is perpendicular to a reference plane, its projection will be a point (no matter how long the line may be). (Line AD.)

Any line oblique to a reference plane will be projected shorter than the true length of the line but greater than a point. (Line DB.)

If a plane is parallel to a reference plane, the projection of the plane will be the same size and shape as the plane itself (no distortion). (Plane ABGF.)

If a plane is perpendicular to a reference plane, the representation or projection (both terms mean the same thing) is a straight line (greatest distortion). (Plane AFED.)

If a plane is oblique to a reference plane, the projection is smaller in area and, with rare exceptions, distorted in shape. (Plane DBGE.)

The projection or representation of any solid is an area. The shape and size of the area are dependent upon the characteristics of the object and the positional relationship between the various parts of the object and the plane of reference.

Up to this point, we have been dealing with an object or geometric magnitude and its projection upon a reference plane. We started with the object and the plane of projection. Let us now begin with the plane of reference and a representation or projection upon *it* and deduce from it the space object or geometric magnitude. In fact, Plates A, B, and C take up this very subject. In Plates A and B, the planes of reference are horizontal planes. In Plate C, the reference plane is a vertical plane.

As far as our method of procedure goes, it remains the same, whether the plane of reference is horizontal or vertical.

1. Begin with a reference plane and a point P on the reference plane. Let us assume that point P on the reference plane represents something in space. The question now arises as to what the possible objects or geometric magnitudes may be that are represented by point P on the reference plane. (Remember that we get the projection of any point on an object by a perpendicular from that point to a plane of reference.)

2. From the projection, point P, draw the perpendicular. Anywhere along the perpendicular just drawn, choose a single point

fig A

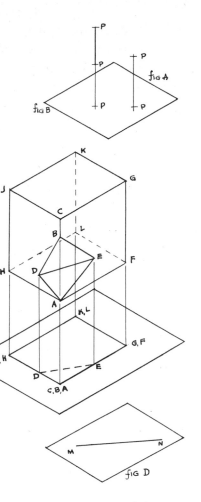

or choose two or more points. If we choose a single point, as in fig. A, we may say that point P on the reference plane is the projection of point P in space. If we choose two points, as in fig. B, along the perpendicular, such as P–P, the line joining P–P will be represented by the point P on the plane of reference.

We may conclude that a point on a reference plane may represent a point in space or a line in space perpendicular to the reference plane. Furthermore, the point on the plane of reference may represent both a point and a straight line. (The point and the straight line must lie in a perpendicular to the plane of reference.)

In fig. C, a rectangular box with the cutouts BDE and DEA are shown. The vertical edges are perpendicular to the reference plane. Note that each of the three edges GF, KL, and JH is represented by a separate point. The vertical edge, CA, has been interrupted by the cutout so that it is now a combination of edge CB and a separate and distinct point, A. However, since CB and point A lie in the same perpendicular line, the projections of the line CB and point A will coincide in a single point.

Suppose we now introduce fig. D, in which the projection on the plane of reference is a straight line, MN.

Question: What are the space equivalents that will result in the given straight line, MN? To answer the question, begin by imagining perpendiculars from each point on the line. Fig. E shows eight of the infinite perpendiculars that may be drawn.

Choose random points on the perpendiculars in fig. F and join them to form the closed figure. The given projection MN will represent the odd-shaped figure just constructed. In fact we may create any number of differently shaped figures, each having the same projection line MN. Figs. G, H, and J illustrate this fact.

We see that a straight line may represent a plane figure or any line in the plane figure not perpendicular to the reference plane.

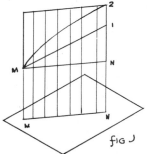

fig K

fig L

fig M

fig N

fig O

In fig. J, lines MN and M1 are emphasized. Both lines are represented by the same line MN. However, in space, line MN is parallel to the plane of reference while line M1 is oblique to the plane of reference. Therefore, the line MN which is the projection of line MN also shows the true length of line MN while MN is shorter than the line M1, the oblique line.

If we consider each of the two lines MN and M1 separate and apart from the plane figure, each may be represented as a separate entity. We may now conclude that the line MN in fig. D may represent a plane figure perpendicular to the reference plane, a straight line parallel to the reference plane, a straight line oblique to the reference plane, or a curved line (line M2, fig. J). (The line MN, the projection on the reference plane, must represent more than a single point in space or a line in space perpendicular to the plane of reference.)

Let us now consider the possible space equivalents of a projection which is an area (fig. K). If we draw perpendiculars from each point within the enclosed space as well as from the contour lines, we shall have a solid in space with the base resting on the reference plane, having the shape of the given projection (fig. L). The space figure is finite if the lengths of the perpendiculars are finite.

For the sake of simplicity, let us consider the four corners of our projection, fig. M, as representing the four corners of a figure in space parallel to the plane of reference. Since the space figure is parallel to the reference plane, each of the four sides is parallel to the plane of reference and the figure is projected or represented without any distortion.

If we assume the four-sided figure in space to be oblique to the reference plane, as in fig. N, the projection does not represent the true size and shape of the space figure but is a distortion of it. (Under unique conditions, an oblique figure may project true shape.)

Our projection may also represent curved surfaces (fig. O).

Finally, the projection may represent an infinite number of different solids (figs. P, Q, R).

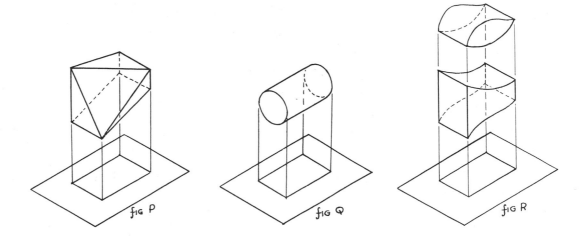

fig P fig Q fig R

We may conclude that an area may represent a plane, or a curved surface, or a solid. The plane area will be projected true size and true shape if the space plane is parallel to the plane of reference.

A *point* may represent a point, or a line, or both.

A *line* may represent a line, or an area, or both.

An *area* may represent an area, or a solid, or both.

Consider the example, fig. S. Notice that only one line has been added to the plan view of figs. N, O, P, Q, and R, but the addition of just this one line intro-duces an entirely different set of inter-pretations. When the plan is a closed area with no subdivisions, as in fig. O, one possible space equivalent may be a

fig S

plane surface. As soon as a line is added to the plan, every space interpretation must represent a three-dimensional figure. Fur-thermore, each line must represent an edge of a surface, or a plane surface, or the intersection between two surfaces. Some-times a line may represent the three possible space equivalents. Many of the examples in the plates in this section illustrate this fact.

Several examples of the space equivalents of fig. S are shown in fig. T.

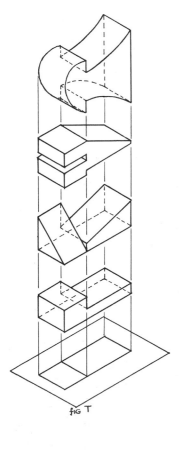

fig T

From a single figure, fig. U, all of the space shapes shown below have been evolved. For each pictorial there is a corresponding working drawing, which consists of a plan, a front view, and a side view.

The plan in each example may be called a top view.

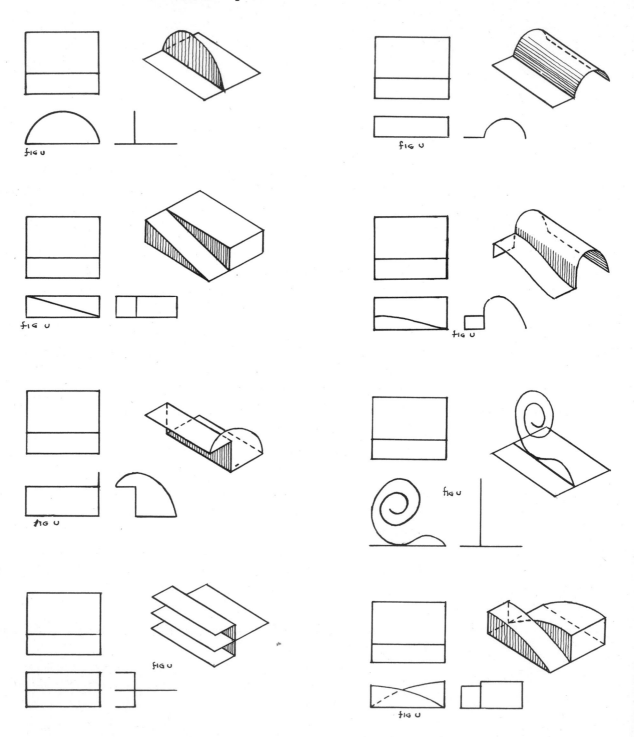

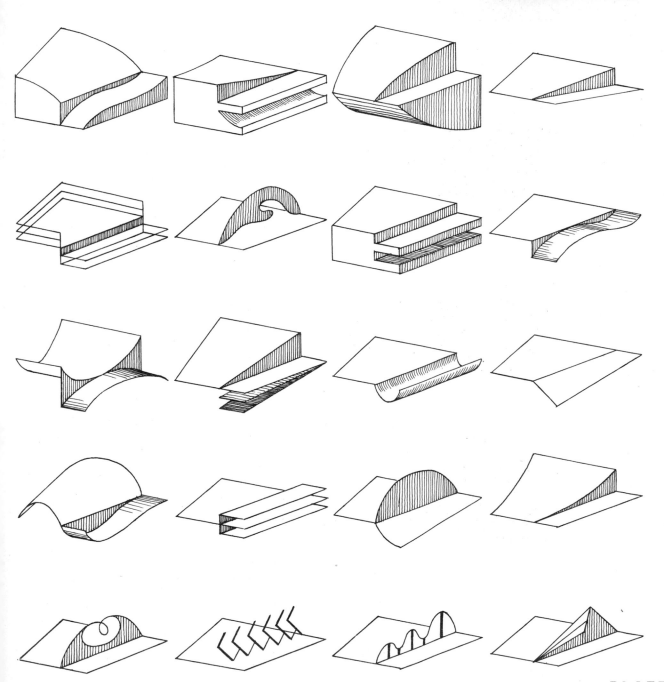

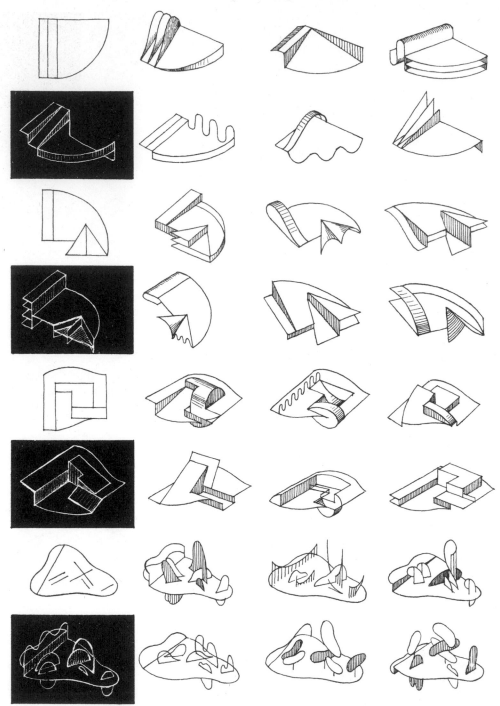

PLATE B

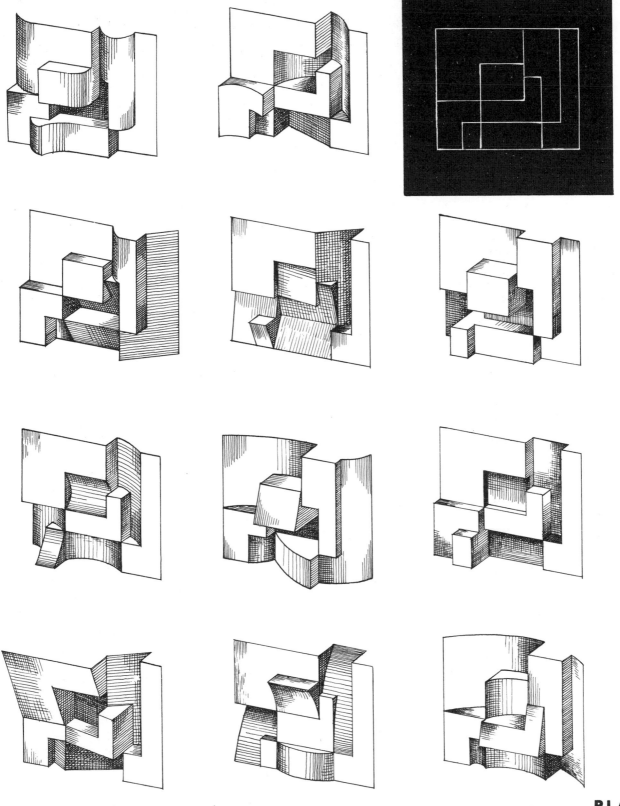

PLATE C

19. REPETITION OF MOTIF

PLATES

A. Modified open triangular prism with rounded corners and edges repeated in varying combinations. Changes in design are made by modifying sizes, shapes, directions, and transition forms connecting the basic solids.

B. Repetition of two-part motif derived from triangular prism. Each variation shows some modification but the general character, at least in part, is maintained.

Repetition is the universal device for creating a design by the extension of a motif into an integrated whole. Repetition gives rise to rhythm, and the kind of rhythm induced helps to give character to the resultant space figure.

fig 1

Fig. 1 shows repetition by parallel change of position (translation).

fig 2

In figs. 2 and 3, repetition is by rotation.

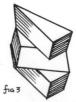

fig 3

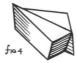

fig 4

Repetition by inversion is illustrated in fig. 4.

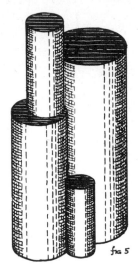

fig 5

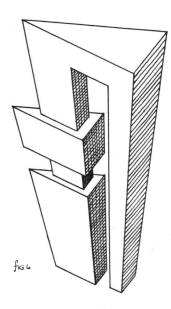

In fig. 5, the repetition is by change of size (same shape).

Repetition of general shape with a change in proportions is shown in fig. 6.

fig 6

Repetition of related motifs is illustrated in figs. 8 and 9.

The greater the number of faces in the pyramid, the more close its resemblance to the cone (see fig. 7). In a like manner, the greater the number of faces of the prism, the more close its resemblance to the cylinder (see fig. 10).

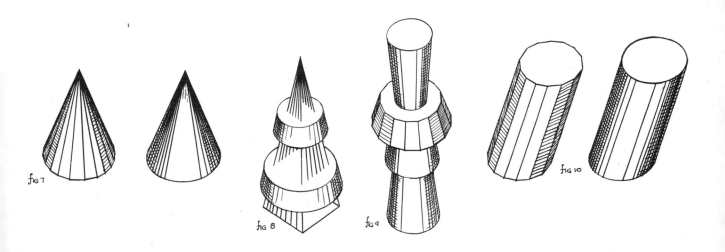

fig 7

fig 8

fig 9

fig 10

PLATE A Modified open triangular prism with rounded corners and edges repeated in varying combinations. Changes in design are made by modifying sizes, shapes, directions, and transition forms connecting the basic solids.

In this plate, the basic motif is a modified triangular prism (see fig. 1). The corners and edges are rounded and the thickness varies. In most cases, the motif has a triangular opening that is in harmony with the outline shape. The change from one position of the motif to another is controlled by transition forms which add variety to

fig 1

the designs through their different space character. Sometimes the transition is a serpentine or a cylindric.

The over-all effect is one of triangulation carrying out the spirit of the basic motif. Interest in the design is heightened by the effective changes in direction and size of the principal parts.

If the transition parts are changed, the character of the design as a whole is considerably altered. In figs. A and B, I have taken Figure 6 from Plate A and created two variations with changes in the transition surfaces.

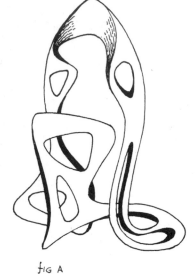

fig A

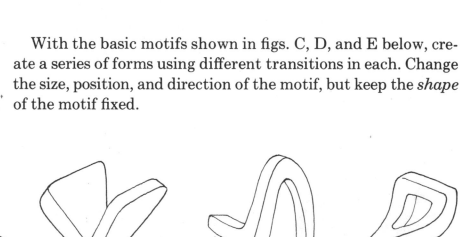

fig B

With the basic motifs shown in figs. C, D, and E below, create a series of forms using different transitions in each. Change the size, position, and direction of the motif, but keep the *shape* of the motif fixed.

fig C

fig D

fig E

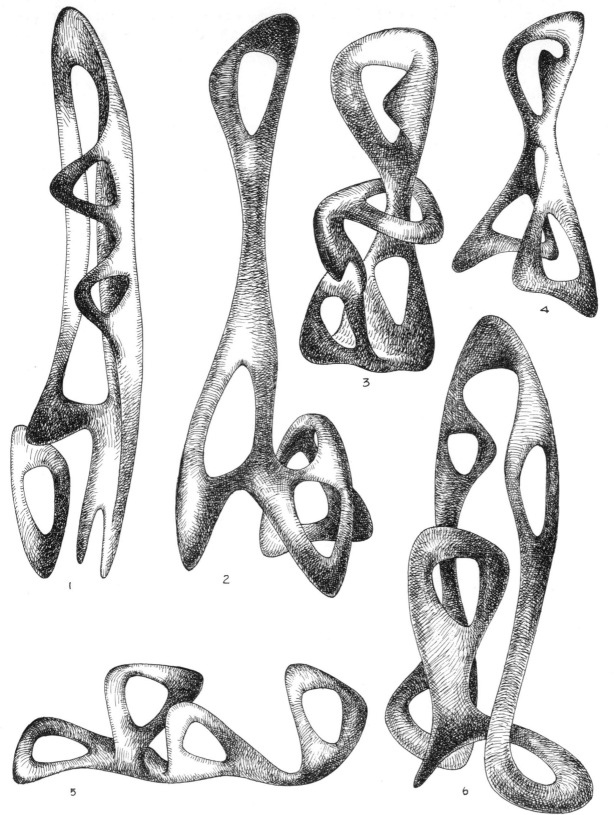

PLATE B Repetition composed of two parts. Each variation shows some modification but the general character, at least in part, is maintained.

The term *related parts* is used broadly to signify that there is sufficient resemblance of the focal volumes to suggest some harmonic relationship. It is a phase of the principle of repetition in which greater liberty is taken in the treatment of each part to give greater variation, and at the same time a feeling of homogeneity is retained.

Figs. A, B, and C, below, are examples of related parts. Always keep in mind the general geometric properties of the key motif. The related parts should have the same general geometric properties. In this way, control of the design can be maintained.

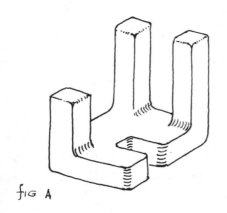

fig A

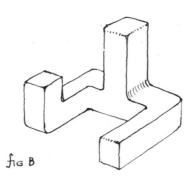

fig B

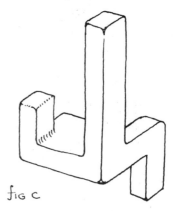

fig C

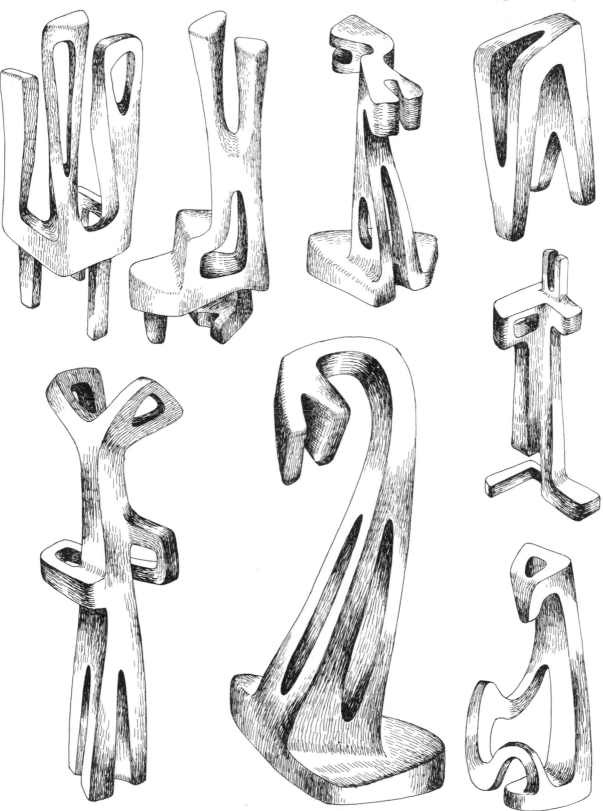
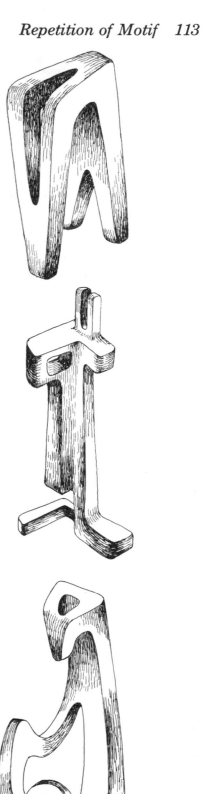

20. RHYTHMIC FLOW OF SURFACES

PLATES

A. Continuous flow of line. Emphasis is achieved by sharp changes in curvature and by marked changes in thickness.
B. Changes in rhythm produced by changes in direction and in the number of elements.
C. Repeated changes in the character of surfaces to heighten the rhythmic effect.

PLATE A Continuous flow of line. Emphasis is achieved by sharp changes in curvature and by marked changes in thickness.

Only in Variation 2 is the continuous flow of line stopped by the intersection of the surfaces. At the lines of intersection, interest is concentrated and the dominant part of the design established. Since the arrangement in general uses a flowing surface, any deviation from it becomes a focus of interest.

In each of the other variations, the flow of surface is interrupted but not stopped. This is a kind of repetition even though there is constant change of direction. The areas of chief interest usually occur where different elements of the design are close together and almost touch or intersect.

In open volumes using continuous flow of surfaces, variation can be produced by (1) changing thickness; (2) making parts touch or nearly touch; (3) introducing *limited* intersecting surfaces (if too many intersecting surfaces are used, the continuous flow character is weakened or lost); or (4) uniting various parts by transition surfaces. This last method is illustrated by the examples in figs. 1 and 2, below.

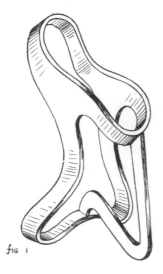

fig 1

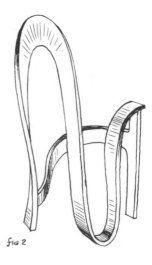

fig 2

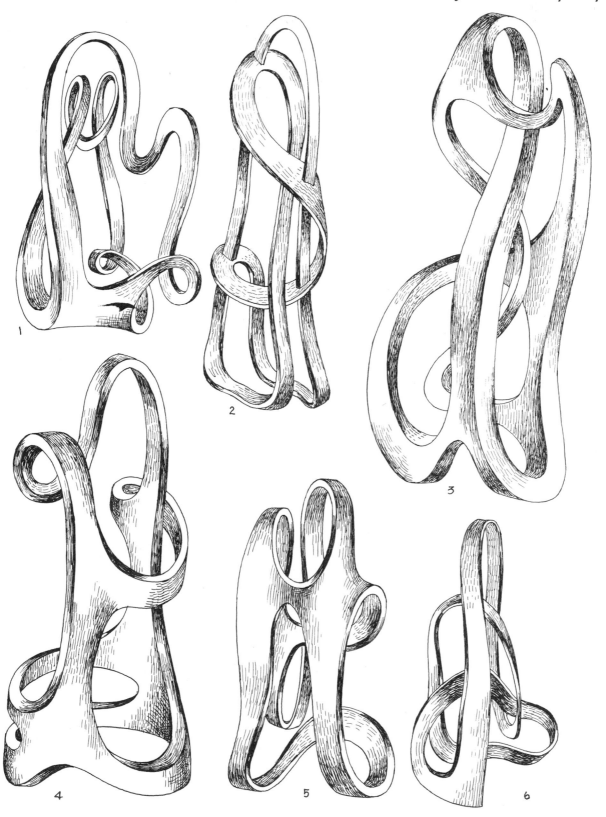

PLATE B **Changes in rhythm produced by changes in direction and in the number of elements.**

In the group of designs in this plate, each figure is composed of two or more dominant parts and the parts are united by means of various transition surfaces.

Figure 1. Parallel vertical grouping of dominants, uniform in thickness and almost rectangular in contour, are united by oblique parallel rectangular transition surfaces. The downward and upward slope of the transition pieces helps to concentrate the chief interest somewhere near the middle of the volume. This type of design often produces a quiet, impressive dignity.

Figure 2. This is composed of two parts united by transition pieces which are an integral part of each unit. The irregular widths and thicknesses add interest to the over-all rectangular effect.

Figure 3. Three dominants in parallel sequence are united by oblique transition pieces. Note the different shape of each dominant although the general feeling of right angularity is maintained. Chief interest is concentrated in the upper part of the design.

Figure 4. Two units varying in size but with almost the same shape are united by four transition surfaces, giving to the design as a whole a sense of movement which carries the eye through the entire volume. The twisted transition surface offers the greatest variation and interest.

Figure 5. Three vertical rectangular blocks vary considerably in thickness. The irregularities in the three dominants lessen the effect of monotony. Interest in the dominant block is further accentuated by the openings which may be regarded as negative cylindrics. The transition surfaces, because of the flow, act as a single unit, but in actuality they are two independent forms. The weight of the dominant unit gives the design as a whole a feeling of substance and volume that is not expressed in any of the other examples in this plate.

Figure 6. Two dominants are united by flowing surfaces which are integral parts of each unit. (Compare with Figure 2.) The soaring effect of the design is emphasized by the elongated unit. The undulating quality adds a sense of movement.

Figure 7. Two large groups of irregular rectangular members are united by cylindric transition surfaces. The change from the vertical creates a sense of motion. The equilibrium has been disturbed by the oblique group. The tensions set up by the change in direction add to the dynamics.

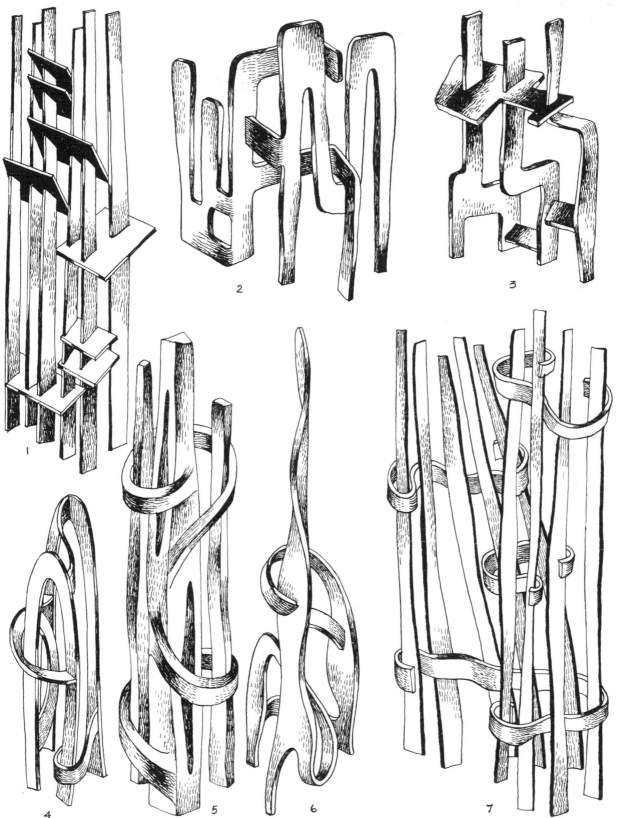

PLATE C **Repeated changes in the character of sur-
faces to heighten the rhythmic effect.**

1. Repetition of shape
2. Repetition of direction
3. Repetition of transition surfaces
4. Related shapes
5. Repetition of feeling

 All five of these ideas are expressed in the six examples of
this plate. Note how important to the design are the diagonal
transitions in Figures 2 and 6. Uniform thickness is used in
each figure. Can you envision a distinct change in the general
character of each design by the change in thickness? Two ex-
amples of this are illustrated in figs. A and B, below.

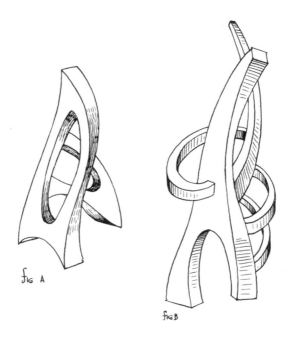

fig A

fig B

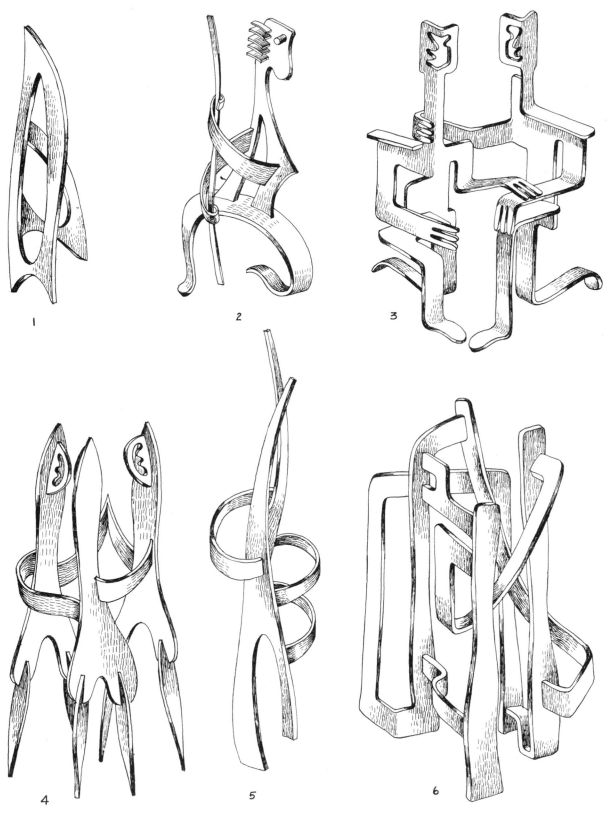

PLATE C

21. ANIMAL FORM

PLATES

A. Cubic interpretations of natural figures.

B. Variants derived from the squirrel.

C. Serpentine and ellipsoidal simplifications. Eight variations of standing figure.

D. Six elephants.

E. Birds especially suited for ceramic and jewelry media.

F. Free interpretations of birds featuring a light airy feeling.

Any study of animal form for design purposes must, as in the case of human form, involve a careful appraisal of each figure and its fundamental divisions and the transformation of the whole of it and its various parts into basic geometric elements.

This is a process of simplification and its operation is essential to the artist and designer. If we cannot simplify, we have not clarified the idea we wish to project. Without the clarification, we alter, change, and confuse our original intent until the end result bears only slight, if any, resemblance to the motivating idea.

In three-dimensional design there is always the problem of construction, the question of how the space figure is to be made. This is of very great importance and cannot be left to chance. The resolution of this question influences the design.

The designer conceives the idea. The nature of the idea, its complexity or simplicity will reflect the thinking of the creator. This thinking process does not just happen. It is the result of all the possible factors of influence that touch the individual. Before he is ready to start the construction process, the idea must become so fixed in his mind that he can see it clearly, at least in its principal parts.

Seeing the idea is aided by sketches, rough models, and more seeing and more sketching and more models, but there must come a point at which the designer decides that the time has come for the final rendition. The final product does not just happen in the twinkling of an eye. It is the result of hard work. There are no short cuts to it.

The process of transforming the idea into the actual space figure involves the following:

1. The idea.

2. Sketches and models of the idea. At first the approximations are very rough.

3. Simplification of the whole idea into a basic geometric equivalent of the idea.
4. Subdivision of basic figure into essential parts.
5. Transformation of the basic figure and its parts into the final complex creation.

Step 3, which introduces the basic simple geometric figure, generally involves selection from many possible choices. Sometimes, in watching an animal curled up, we immediately think of a spherical mass as the closest approximation of the general shape of the figure. The interpretation is so obvious in this case that we at once sense it without any question, but by and large, we seldom run across a figure that lends itself to such a simple equivalent. Strange as it may seem, there may be several simple equivalents, each having its own validity and each expressing to a considerable degree the general action and character of the original.

Whether the idea is realistic or abstract, the designer working three-dimensionally has a building problem on his hands. The simplest way to handle the building or construction phase is generally the best way. The building must proceed from the simple and become more involved as the process continues. The basic simple equivalent plays a major role in the steps necessary for the resolution of the idea into reality.

When the space figure is completed, the creator has done his job, but he is not yet finished. The actual work has been carried to completion and he may already be thinking about something entirely new, but there is always the searching and troublesome question of whether he is completely satisfied with his work. It is in this sense that we may safely say that no work is ever finished.

PLATE A **Cubic interpretations of natural figures.**

Like human forms, bird and animal figures do not have straight edges nor plane surfaces. They are complex creatures always on the move, especially when you try to sketch them. Memory must play an important role and in order to aid our retentive faculties, we must reduce to the simplest possible forms the natural volumes involved:

1. The simplest geometric equivalent of the figure as a whole.
2. The large natural divisions.
3. The simplest geometric equivalent of each division.
4. Relative sizes of the natural divisions.

Observation must precede drawing and modeling. When observation is controlled, as suggested in the four steps, it is not only easier to record what is seen but it is easier to recall it for later use. Perhaps most important, when shapes, sizes, and movements are clearly defined in one's mind, transformations into new forms can be more easily achieved. There is a truism which states that in art, simplification comes only when the artist knows what to leave out. It can be stated in general terms that any change from the natural form involves knowledge of the forms to be changed. Marked changes in form and extreme simplifications are not the product of chance and uncontrolled feelings and emotions, but rather the product of long experience resolved into exciting summaries.

The basic solids are comparatively few and a mastery of their general properties is of the greatest importance to the designer. In all of the plates using animal and human form, we see striking evidence of the intimate relationship between expressions in form and the knowledge founded on a study of the basic figures.

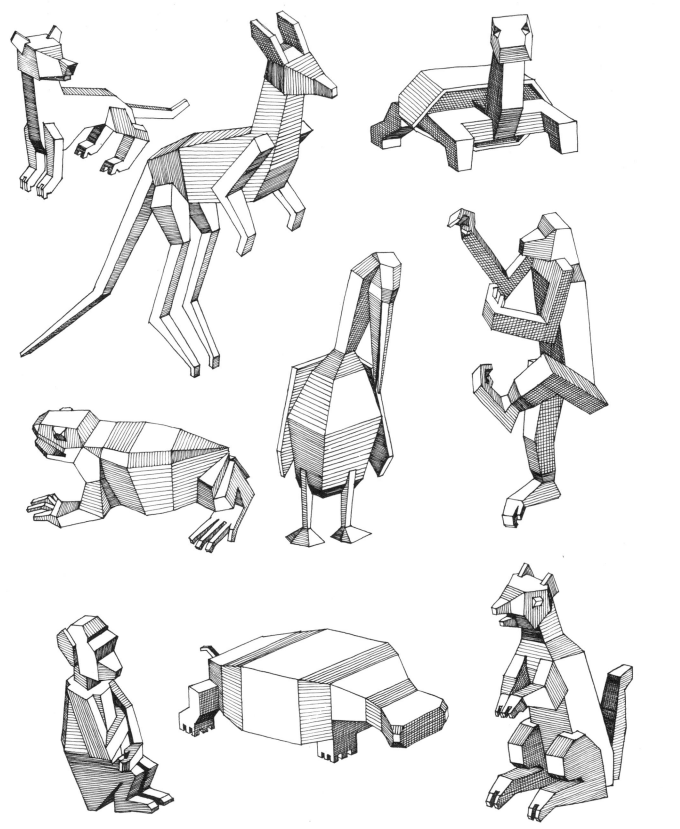

PLATE A

PLATE B **Variants derived from the squirrel.**

The three large basic geometric equivalents of the natural form are (1) prismatic solids, (2) ellipsoidal solids, and (3) sheet surface solids.

Figures 3 and 6 have all plane surfaces.

Figures 2 and 5 have all curved surfaces (spherical, elliptical, and serpentine).

In Figures 1 and 7, cylindrics are dominant with helicoidal surfaces.

Figure 4 is a combination of cylindric and plane surfaces.

Figure 8 is a combination of cylindric and spherical surfaces.

Figure 9 is a combination of plane, cylindric, and helicoidal surfaces.

Figure 3 shows the greatest simplification of all the variants. It represents the first step in blocking out a figure from a volume of stone or wood. No attention has been paid to detail. Of primary importance are the action and the relative proportions of the major parts.

From a study of the designs, it can be seen that the action of the natural form has been quite faithfully retained. In other respects there has been considerable divergence from the rather squat chubby squirrel.

The intent of the artist affects the final result of his work. As a good problem in making form convey your meaning, use the same figure in different arrangements to express different things. At times the source material is so striking that its effect on the creator is overwhelming and he sees it in only one way. If that happens, the best thing to do is to express this feeling and then go to something else for experimental purposes.

The artist is very much affected by ideas as well as things. The things have a constancy that ideas do not have. When an idea forms the basis for a design, it is only the composition that is three-dimensional; when reality is the inspiration, we start with a three-dimensional object that always retains its shape and may always be used for reference. For this reason it is more difficult to work from ideas and memory and because it is more difficult, it is of the greatest importance to the designer to do it.

PLATE C **Serpentine and ellipsoidal simplifications.
Eight variations of standing figure.**

Figures 1, 2, 3, 4, 5, and 6 show coiled treatment of the animals. The coils are sometimes circular, sometimes elliptical, short or elongated, tapering or uniform in width. There is wide variation possible and the coil method offers a comparatively easy way of experimenting with three-dimensional form.

Figure 6 forms the basis for the eight variations 7, 8, 9, 10, 11, 12, 13, and 14.

In these examples, I considered the problem of design as essentially one of creating transitions between the head and front legs, the front legs and hind legs.

We can create an entirely different group of figures if we use the following transition groups:

1. Head, right front leg, and right hind leg; head, left front leg, and left hind leg (fig. 1, below).
2. Right front leg and rear left leg; left front leg and rear right leg; head, front left leg, and front right leg (fig. 2, below).
3. Head, rear left leg, and rear right leg; front right leg, front left leg, and rear legs (fig. 3, below).

Invent other combinations of your own.

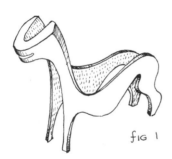
fig 1

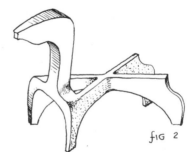
fig 2

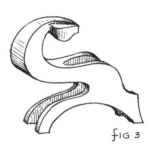
fig 3

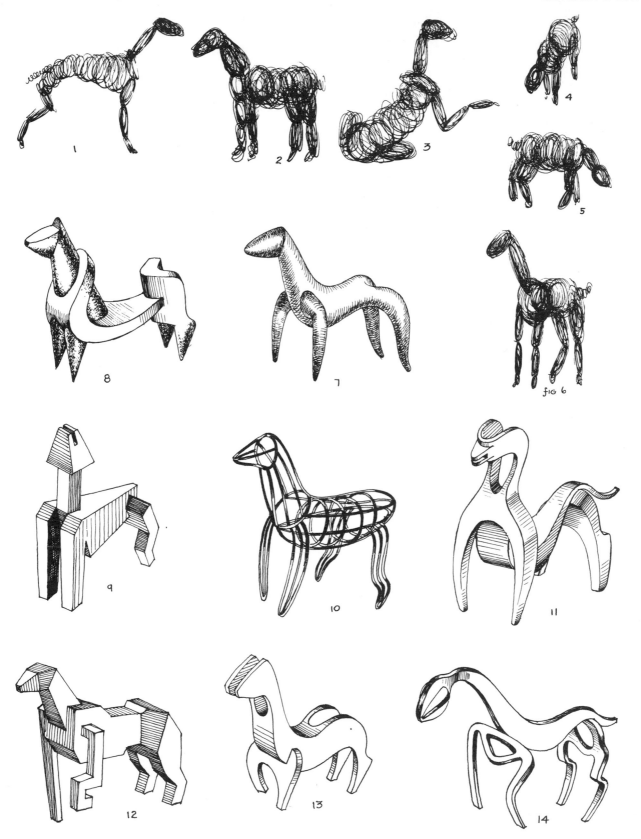

PLATE C

PLATE D **Six elephants.**

These six variations of the elephant consist principally of plane and cylindric surfaces.

Figure 4 is all plane surfaces.

Figures 1 and 3 are almost all cylindric surfaces; there is spare use of plane surfaces.

Figures 2 and 5 make use of dominant cylindric and subdominant plane surfaces.

Figure 6 is a combination of cylindric and conical surfaces.

Even though five of the six designs are open and composed of sheet surfaces, the general effect of massive weight is conveyed in each one. The underlying idea associated with the elephant, after a great deal of observation, study, sketching, and model-making, was to treat the figure with a light touch and convey some humor without sacrificing the feeling of power and substance.

I mention this because design doesn't just happen. As I have stated in other sections of this book, the automatic, uncontrolled, random, accidental effect is too uncertain in its ultimate merits to be relied upon. Our thinking for art production must be positive and concrete, and must exist in terms that can be produced artistically. This does not rule out flights of fancy, dreams, the subconscious, or any other kind of art stimulation. It merely means that before the artist in three dimensions can execute his work, he has to have a clear idea of what he wants to do. This is a problem that confronts the painter as well as the sculptor, but the difference is that if there is indecision or mistakes, it is a lot easier for the painter to make corrections than it is for the sculptor, particularly if the sculptor is removing huge chunks of wood or stone.

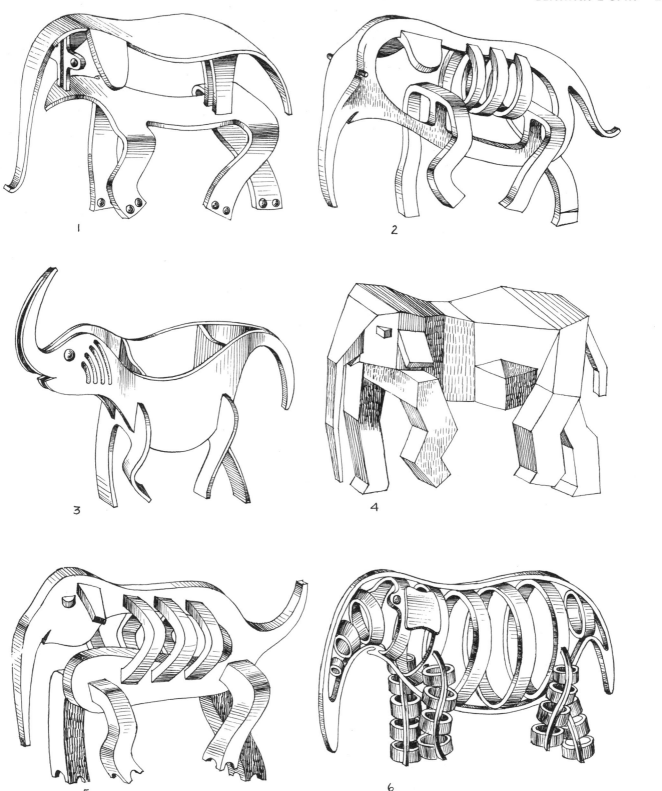

1

2

3

4

5

6

PLATE D

PLATE E **Birds especially suited for ceramic and jewelry media.**

The fourteen designs in this plate were made in silver.

Figure 1 consists of four soldered parts. Three were cut from sheet stock. The eye was cut from a piece of round wire.

Figure 2 consists of three parts: the eye, composed of circular ring and ball, and the body, made of one piece of sheet stock and transformed into cylindric by shaping with pliers.

Figure 3 consists of five parts. Variations in thickness were produced by pounding sheet metal and then shaping it to produce combinations of plane and cylindric surfaces.

Figure 4 consists of five parts, three cut from sheet stock. The eye is spherical; the cylindric joining piece is made from a long piece of stock wire shaped with pliers.

Figure 5 consists of four parts. The wings and legs were formed from one shaped piece of sheet stock and then converted into a combination of plane and cylindric surfaces.

Figure 6 consists of three parts. The round wire is shaped with pliers. The other two parts are cut from sheet stock.

Figure 7 consists of six parts: spherical ball; cylindric back and plane surface body; head; and legs. All the parts with the exception of the ball are cut from sheet stock. The back line is shaped with pliers.

Figure 8 consists of eight parts. The bodies of both birds consist of one piece turned and twisted to form a combination of plane and helicoidal surfaces.

Figure 9 consists of six parts. The cylindric parts are shaped from flat wire.

Figure 10 consists of four parts. The body is one piece cut from sheet stock and converted into a twisted surface.

Figure 11 consists of four parts. The two cylindric eyes are cut from round stock. The remaining two parts are cut from sheet stock and converted into cylindric surfaces.

Figure 12 consists of four parts. The body and leg were cut from sheet stock. The eye was melted into a ball from thin wire. The fourth part was cut from a long piece of square stock.

Figure 13 consists of six parts. The neck was converted into a cylindric surface, and the body was converted into a partial toroidal surface by shaping the two rounded corners and tail.

Figure 14 consists of four parts. The body and legs are composed of one piece with the legs converted into cylindric surfaces. The wing and the two sections which are the neck and head are soldered to the body. The neck part has been formed by stretching and pounding to produce the warped surface.

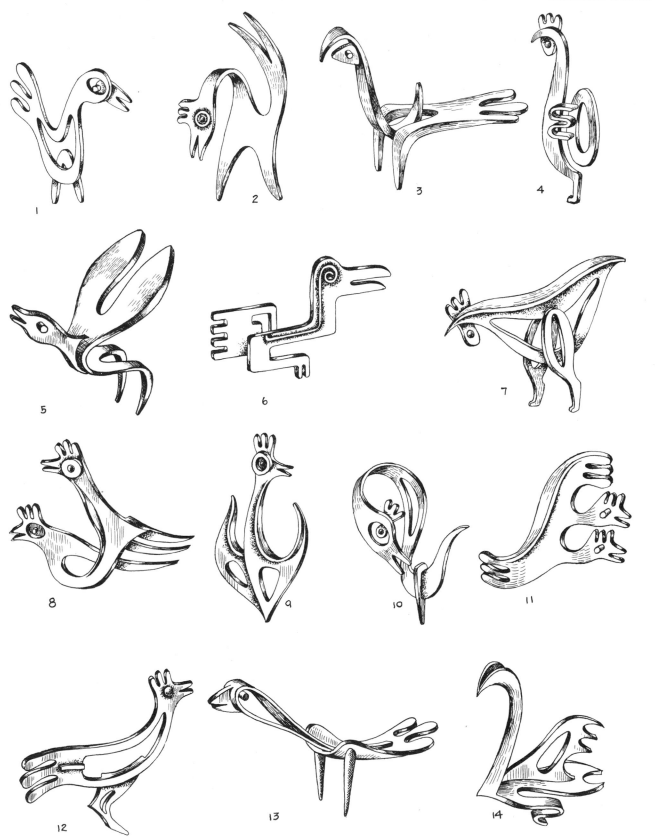

PLATE F **Free interpretations of birds featuring a light airy feeling.**

The bird may be divided into six major divisions:

1. Beak (generally conical in shape);
2. Head (generally spherical in shape);
3. Body (generally ellipsoidal in shape);
4. Legs (generally conical in shape);
5. Wings (thin prismatics, rounded ends);
6. Tail (generally fan-shaped thin, sheet surfaces).

As has been suggested in Plate C this section, we can create combinations of various parts of the basic figure and unite them by means of transition surfaces.

Emphasis on any combination or on a single part will help determine the character of the over-all design and will influence the treatment of the remaining parts.

A study of the structure and movement of the wings and legs will aid in adding source material that can be converted to the creation of sculptural form.

Of course, a knowledge of the structure of all the material used in creative design is important. This includes the human form as well as plant, animal, and geometric form. Can one know too much about structure? I doubt it very much. Most often the difficulty lies in the fact that we do not know enough about the basic figures with which we work. Our aim should be to expand our interests and knowledge and experiences and make them part of our tools and equipment for the fullest expression of our ideas. When we reach a point where we repeat ourselves too much or seem to have no ideas, that is a good time to stop and take stock of our resources. We have in a sense exhausted our material and we must take time out to replenish ourselves. This can be achieved only through further investigation, study, and experiment.

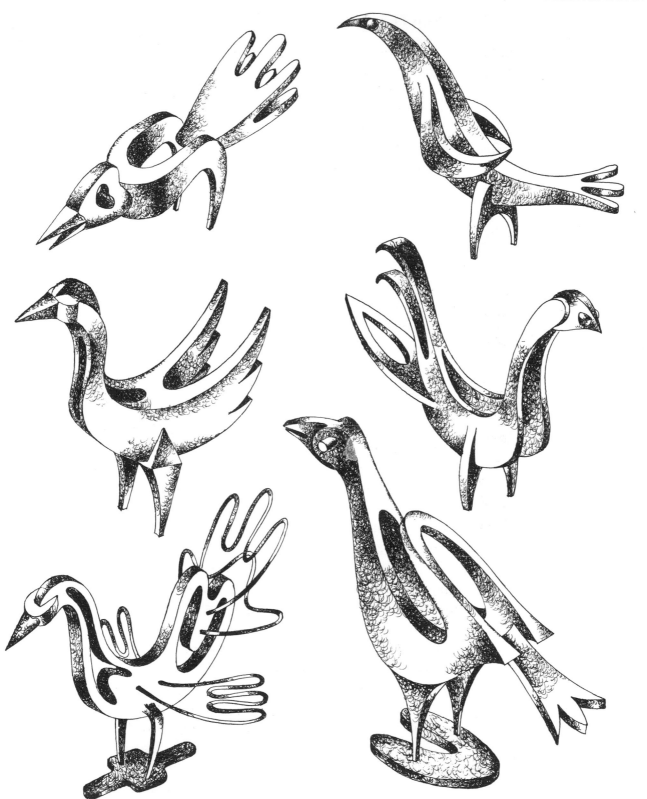

22. THE HUMAN FIGURE

PLATES

A. The skeletal wire figure.
B. Variants based on Figure 2 of Plate A.
C. Variants based on Figure 1 of Plate A.
D. Variations on a theme.
E. Angular interpretations of the human head. Subtraction from single block or additions of pyramidal and prismatic blocks.
F. Sheet figure compositions.
G. Motion, tension, flow of line.
H. Repose, opposition, continuity.
I. Open-figure compositions, showing thickness variation.
J. Dancing figures, individually and in combination.
K. Block and pyramidal derivatives.
L. Pyramidal variants with considerable changes in thickness.
M. Wire-line figures allowing free interpretation of surfaces.
N. Sheet and wire compositions.
O. Musical figures.
P. Variants showing the interplay of concave and convex surfaces.

Of all the available sources of inspiration for the designer, none exceeds the human figure in subtlety and complexity. The visual aspects of the human form comprise many varying types of surfaces, with the possible exception of the plane surface. It is this richness of material that opens the way to expressive interpretation aided by the innate talents of the designer and his continuing perseverance in experimentation.

Interest in any one field is never sustained at the same level. It is like the tide that runs out. For us, high tide comes again only if we make the effort to renew and revitalize the healthy, curious, searching interest without which our work becomes matter-of-fact, routine, and spiritless.

The most practical way to express ideas three-dimensionally is with wire and plasticene. This does not rule out preliminary sketching. Any device that will aid in giving permanence to an idea is extremely useful. However important the drawing may be, it is not three-dimensional and therefore cannot convey precisely what is in the designer's mind.

Thinking in space, not the illusion of space, requires the constant making of models. It involves the ingenious use of sheet metal, clay, paper, wire, and wood and the proper use of tools with which to create the actual shapes. The hands must be regarded as any other tool and must be trained.

The man who designs a space figure of any kind ought to be able to make it. Knowing how to make something undoubtedly plays an important role in the designing aspect of it. I have suggested elsewhere in this book that it is a mistake to say categorically that this or that design is totally unsuitable in material x. At the same time I am fully aware of the important fact that the structural phase of a problem in design cannot be ignored.

The physical limits to which wood and metal and a host of other substances may be subjected have to be understood if the results are to express completely the intention of the creator.

There is no quick or easy way to gain sufficient mastery so that the idea and the final three-dimensional result are in complete rapport. There are no tricks, no sleight-of-hand, no magic formula by which this can be accomplished. Hard work and lots of it is the only way satisfactory results can be accomplished.

While I have given a secondary role to sketching, I wish to emphasize the fact that I regard it as of the greatest importance. It is impossible to state with complete assurance that one or another of several possible choices is the most desirable. This kind of thinking immediately results in a grading system which creates artificial preferences. The idea comes first. Then comes the expression of the idea. Almost always, the first expression of the idea is a sketch. The drawing may be crude, extremely simple, or quite elaborate, but whatever state it may be in, it is probably the quickest way for the designer to help fix his idea.

The sketch is preliminary also because it is only another step toward the ultimate object, the space figure. Then come the three-dimensional experimental figures that express the thinking of the artist. He finally arrives at something that satisfies him. The end result is not yet in sight, particularly if the final experimental model is to be considerably enlarged. Size makes a difference. In the case of the small model, where the eye can encompass the whole figure and where the sense of it can be embraced immediately, our reaction is of one type; when we come upon a figure which cannot be taken in in one glance, the designer must be sure that every part of his creation is interesting and has some of the dynamic quality with which he hopes to invest the figure as a whole. To do this very often

means that the perfect small-sized figure must be changed to meet the demands imposed by size. Incidentally, the problem of change due to size is one that frequently plagues the mural painter as well as the sculptor, the dramatist as well as the novelist. I wonder, for example, how many perfectly good one-act plays and short stories have failed when enlarged to three-act plays and complete novels.

Since all parts of the human figure are composed of rounded forms, the transition in design from the actual figure to a simpler curved one involves less change than the transition from the real to a cubic figure. This holds true for first approximations, but as the relative sizes and shapes of the various parts of the body are changed and distorted, the similarity decreases until the final curved massive object has attained a degree of abstraction equal to anything that can be achieved by cubic simplification.

Natural form for the most part is composed of rounded surfaces. The obvious thing is to think in terms of the curved surfaces and to use them first in the creation of design. The use of the plane surface and angular forms is much more of an intellectual process. It does not arise from visual experience except as man-made objects influence the observer.

Every design represents the combined forces of emotion, observation, and intellect operating in harmony—not necessarily in equal amounts nor with equal intensity, but whatever the proportions, they are ever present.

The examples on this page and the next (figs. 1 through 10) illustrate the use of various shapes and surfaces in drawing the

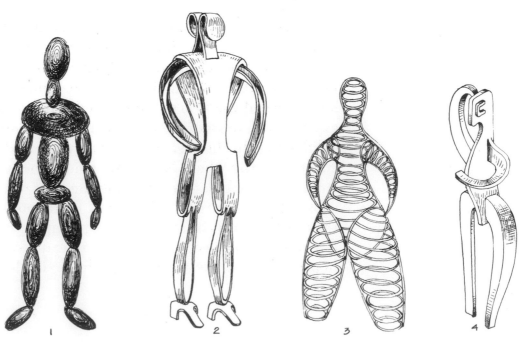

1 2 3 4

human figure. In fig. 1, ellipsoids are used; fig. 2 is a sheet and ribbon combination. In fig. 3, toroidal and serpentine surfaces are combined; fig. 4 is contrasting sheet and mass.

Fig. 5 employs continuous surfaces with transition from plane to cylindric. Prismatic combinations are used in fig. 6. Pyramidal and prismatic combinations make up fig. 7. Cylindric surfaces with transitions to planes are shown in fig. 8.

Fig. 9 is made up of cylindric sheets; fig. 10 is plane surface sheets.

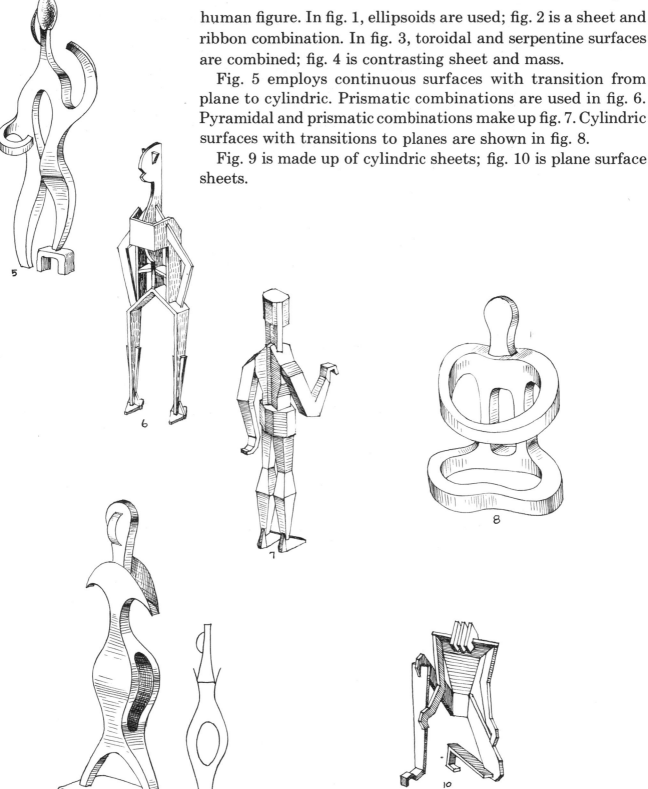

PLATE A **The skeletal wire figure.**

These wire figures were made from 19 and 26 gauge wire. The 19 gauge wire is heavy enough to stiffen the figure and at the same time is easily bent into any desirable shape. The 26 gauge wire is used as filler and is extremely pliable.

It is quite a simple task to fill out the shapes formed by the stiff wire to rounded forms. While this is not illustrated in this plate, it is shown in one of the variations in Plate D and in some of the animal figures in the preceding section.

The use of wire is recommended for several reasons:

1. It is easily handled.
2. It permits considerable movement of the various parts.
3. It forms a permanent armature if the design is developed by the use of plaster of paris or plasticene.
4. Variations from realistic figures can be more easily visualized and created.
5. It emphasizes the aspects of motion in the human figure.

The wire figure features *line* as the basic geometric element from which form is evolved. This is not the only approach to the general problem of transforming the realistic figure into a design shape but is a very good way to begin, particularly if the designer has not had very much experience with human form.

Keep drawing the human figure from models and from memory. That is one of the most important ways to accumulate a storehouse of knowledge and experience that will be of great use.

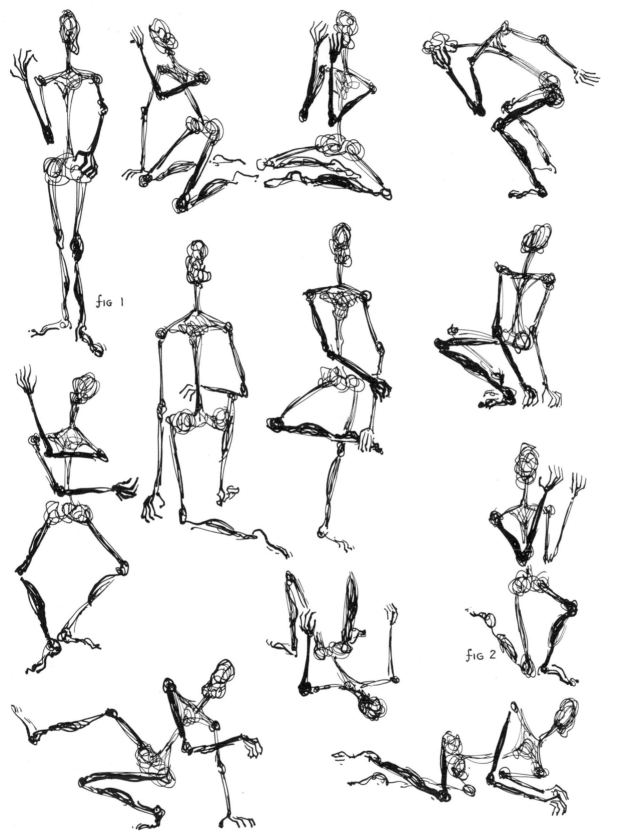

fig 1

fig 2

PLATE B **Variants based on Figure 2 of Plate A.**

This plate shows one angular interpretation and three curvilinear treatments.

Figure 1 is the ribbon surface with open free-form curve. All of the contour lines are curved. There is uniform thickness of all parts.

Figure 2 uses contours which are smooth-flowing curves. Changes in thickness with the greatest thickness in the legs and feet give this Figure a feeling of greater mass, weight, and stability than Figure 1. As in Figure 1, the general effect of the over-all design is free-flowing. The head and neck arrest the flow of line, creating a dominant volume that is in opposition to the lower portions of the figure.

Figure 3. As in Figures 1 and 2, all of the contour lines are curved with the exception of the relatively unimportant straight line contours of the fingers. The general effect is cubic. The adjacent surfaces intersect in sharp edges and corners. Changes in shapes and directions are sudden and give an incisive character to the total figure.

Figure 4 is composed entirely of straight edges and plane surfaces. It is a highly stylized assembly of prismatic forms. Even though cubic in conception, it does not have the feeling of massiveness expressed in Figures 2 and 3. This is partly due to the almost uniform thickness throughout Figure 4. Dominance is retained in the upper portions of the figure because of the similarity in treatment of the head, torso, and pelvis.

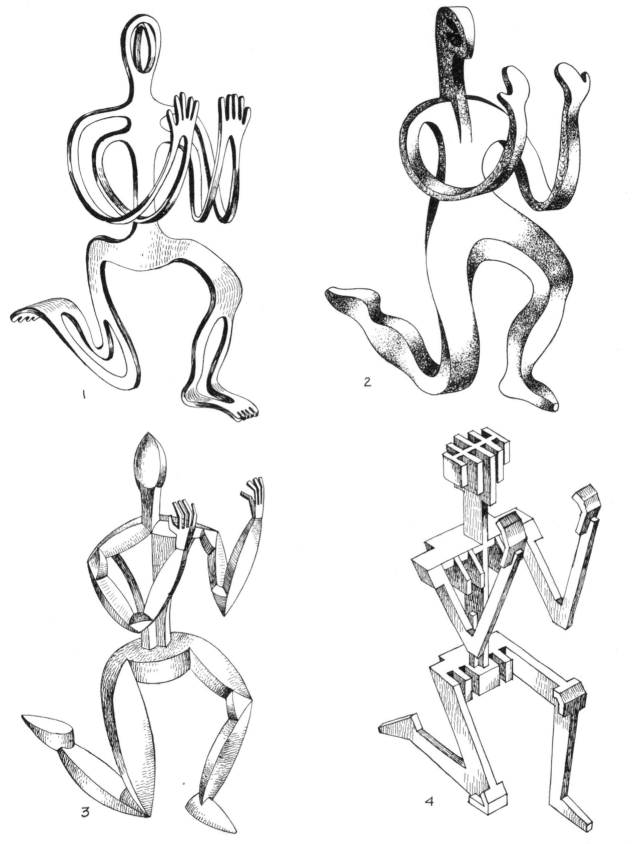

PLATE C **Variants based on Figure 1 of Plate A.**

In this plate, the three variations are all planes, all curves, and a combination of planes and curves. Each figure shows considerable variation in thickness. This is very important in sculptural design because both the thin and the thick parts are emphasized. Furthermore, the transitions from thin to thick and from thick to thin add dynamic contrasts to the flow of lines and surfaces.

Figure 1. Combinations of prismatic and pyramidal volumes compose this form. The corners and edges are sharp. Try to envision this figure with the corners and edges rounded. While the basic parts would remain the same, the general effect would be quite different.

Figure 2 is an extension of the ribbon form of Figure 1 in Plate B. Changes in thickness add weight to the figure and give it more stability. In constrast to Figure 1 of this plate, all the surfaces are curved and the edges are closed space curves.

In Figure 3, there are combinations of plane and curved surfaces. While the plane surfaces are of lesser interest, they serve as contrast and thus increase the vitality of the design.

Note the difference in treatment in each figure of the head, the torso and the pelvis. Plates B and C (which show how two of the twelve figures of Plate A are used to create more fully realized three-dimensional designs) point up the fact that countless ideas can arise from comparatively simple studies.

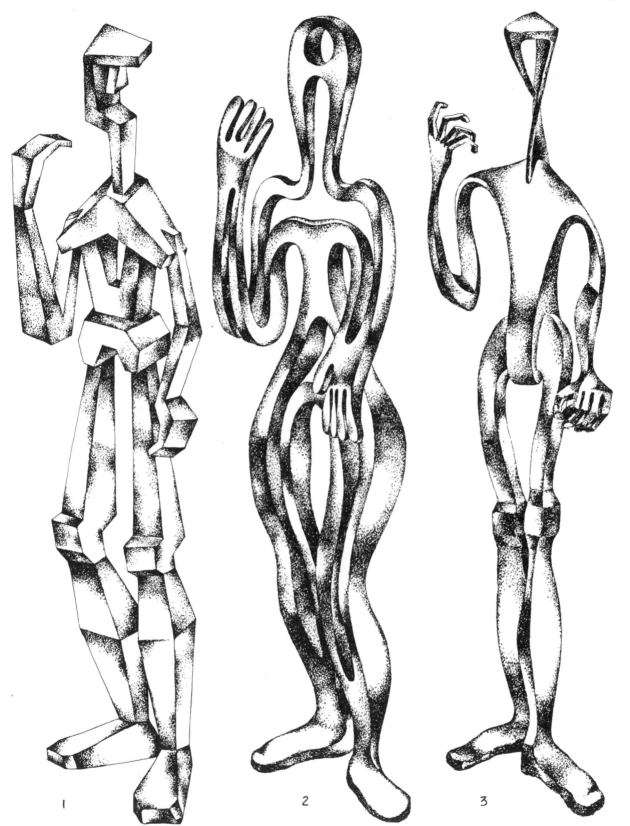

1

2

3

PLATE C

PLATE D Variations on a theme.

The seated figure, A, forms the basis for the eleven variations in this plate.

Figures 7 and 11 are wire figures.

Figures 1, 3, and 9 are combinations of wire and sheet surfaces.

Figures 8 and 10 are sheet surfaces.

Figure 2 uses cubic forms with contrasting rounded surfaces.

Figure 4 is a combination of prismatic and pyramidal surfaces with varying thicknesses.

Figure 6 uses prismatic surfaces with uniform thickness.

Figure 5 is a variation of Figure 4 through subdivision into a greater number of prisms and pyramids and the rounding of some of the edges to create curved surfaces.

The sheet surfaces represented in this plate are, for the most part, plane surfaces. In Figures 1 and 10, twisting transforms the surfaces into three-dimensional figures. The sheet surfaces of Figures 3 and 8 are cylindric. In Figure 8, the unique design is achieved by repetition of the basic cylindric.

The wire Figure 11 may be viewed as a composite of coiled shapes. The coil lends itself readily to many curved surfaces, such as closed cylindrics, conics, and serpentine and toroidal shapes.

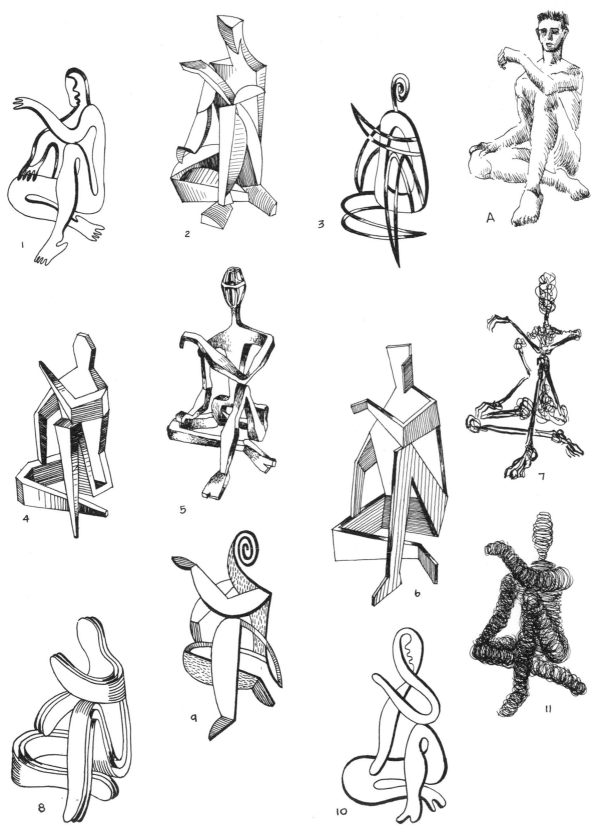

1

2

3

A

4

5

6

7

8

9

10

11

PLATE E Angular interpretations of the human head. Subtraction from single block or additions of pyramidal and prismatic blocks.

These sixteen variations of the human head may be classified as (1) all prismatic, (2) all pyramidal, or (3) combinations of prismatic and pyramidal.

Figures 1, 2, 7, 8, and 9 are all prismatic.

Figures 3, 4, 5, 6, 10, 12, 13, 14, 15, and 16 are combinations of prismatic and pyramidal.

Figure 11 is all pyramidal.

The basic figure from which all of the heads were evolved is the rectangular block. Each form represents a process of subtraction in which prisms and pyramids of varying shapes and sizes were removed.

Choose any one of the figures. For example, let us take Figure 1. Study it carefully so that when you turn your head from the design, you have a clear mental picture of it. Try to imagine how the head will look when some of the surfaces are rounded. Then carry the change forward so that all of the surfaces are curved.

I have suggested this mental exercise because it is a very good way to stimulate the imagination. Sketch the new combinations you have evolved, and whatever else you do, create original heads from the basic rectangular prism and work from them. When you get something you like, make a model of it out of clay, plaster, plasticene, paper, or any other material you may wish to use. No matter what it looks like on paper, the real thing, the three-dimensional block, will have a different look. The space figure is the one that counts.

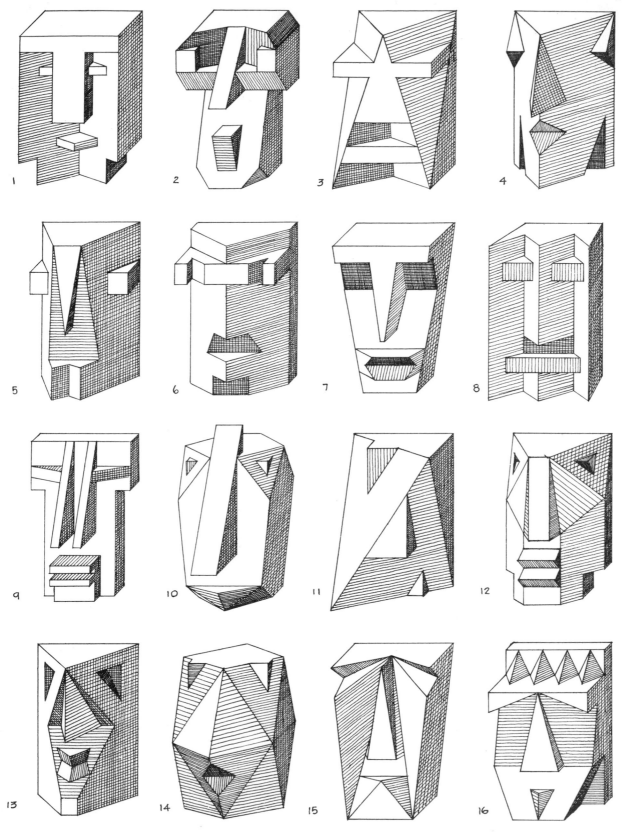

PLATE F **Sheet figure compositions.**

The nine sculptural compositions in this plate, all involving three figures, are all made from sheet surfaces. They lend themselves to any kind of sheet metal that can be cut and rounded easily. The figures need not be made of the same gauge metal. Clay, a medium of very great flexibility, may also be used.

At this point, it may well be asked whether metal and clay may be freely interchanged as equally suitable for the creation of a specific design. I think of the nine figure arrangements in terms of metal. When I ask myself whether the same groups, treated as sheet surfaces, would satisfy me if made from clay, I answer that I cannot see them in clay unless a feeling of greater mass weight is imparted to each composition. In terms of clay, I would have varying thickness and varying curved surfaces. Each of the designs is essentially a combination of plane and cylindric surfaces with an occasional twisted surface. To the two basic surfaces, I would add spherical and ellipsoidal surfaces in clay.

I wonder how I would react to the nine figure groups if I had originally made them in clay; if working in clay, would I have created the groups as they now appear in metal? There is no question about it. The medium in which the designer works has an important bearing on the things he creates.

It is a good idea to try the same design in different media. This is a good way of becoming aware of the differences in media and also becoming sensitive to each one.

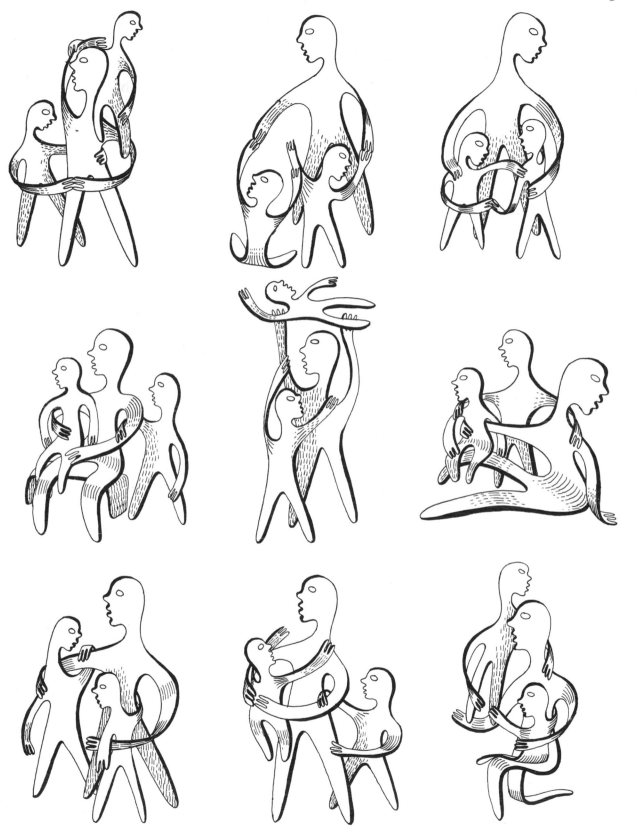

PLATE F

PLATE G **Motion, tension, flow of line.**

The eight compositions in this plate were made in clay from rectangular blocks. The excess material was cut and removed, leaving the ribbon and sheet-like figures.

In Plate F, the sheet figure compositions, the process was one of addition. In this series, subtraction is the process. The thinking in each process is different and the techniques vary considerably, even though the final results are not far apart.

It is much easier to create varying thicknesses and varying curvatures in clay than it is in metal. Clay lends itself more readily to the will of the designer. Metal has to be pounded, bent, and heated before it responds.

In Figure 3, tension is created by the sense of downward motion in the joined arms of the two lowest figures in opposition to the upward motion suggested by the upside-down figure. The two parts are not of equal importance. The sweep of the rising surfaces gives greater value to the head-down figure.

In Figure 7, the small figure is moving forward while the larger figure is pulling back in opposition. Opposition is thus created, giving rise to the feeling of tension.

Almost every three-dimensional composition expresses to some degree the feeling of tension. Sometimes it is shown by (1) changes in direction, (2) changes in shape, (3) changes in areas of interest or (4) changes in mass weight. Any or all of these four kinds of changes may occur in a design. Generally, the most dynamic composition will employ the greatest number of changes in tension.

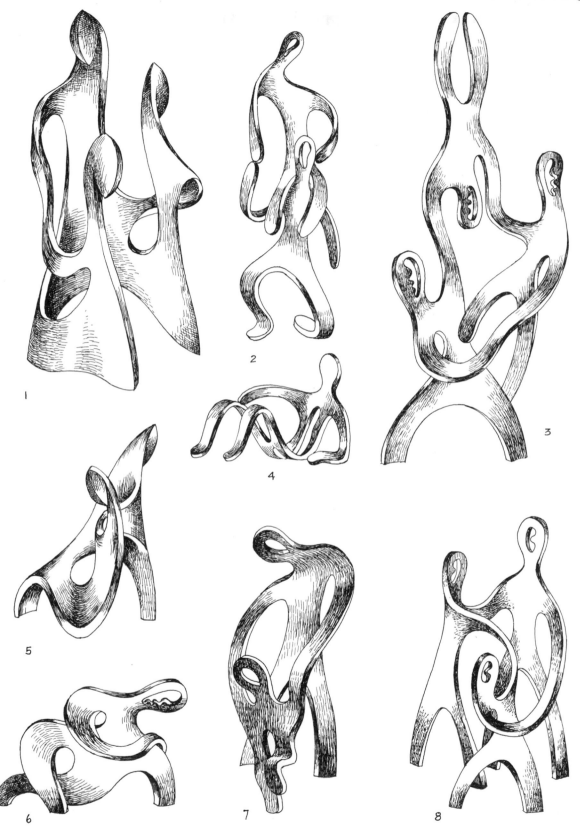

PLATE H **Repose, opposition, continuity.**

Figure 1, which is cylindrical in character, has the feeling of greatest repose. The figures are vertical with only slight changes in direction. The sense of flow of line is created by the parts joining the figures.

Figure 3 also has vertical figures, but there is a greater change in direction of the figures than in Figure 1. This lessens the feeling of repose. The action is more lively.

Figures 2 and 4 show the greatest contrast of movement and direction, giving rise to the greatest amount of tension.

Note how in Figure 2 each figure is insistent on claiming our attention. At the same time, the figures are united so that there is flow from one to the other and back again. In this figure, there are several stoppage points at which the eye comes to rest momentarily, while in Figure 4 there is only one stoppage place. This gives Figure 4 greater continuity of flow.

Figure 5, a composition of four figures, has a feeling of continuous flow of line and surface. The sense of verticality is somewhat modified compared with Figures 1 and 3. The marked change in direction of the three principal parts, together with the twisting effect, help to create a dynamic feeling.

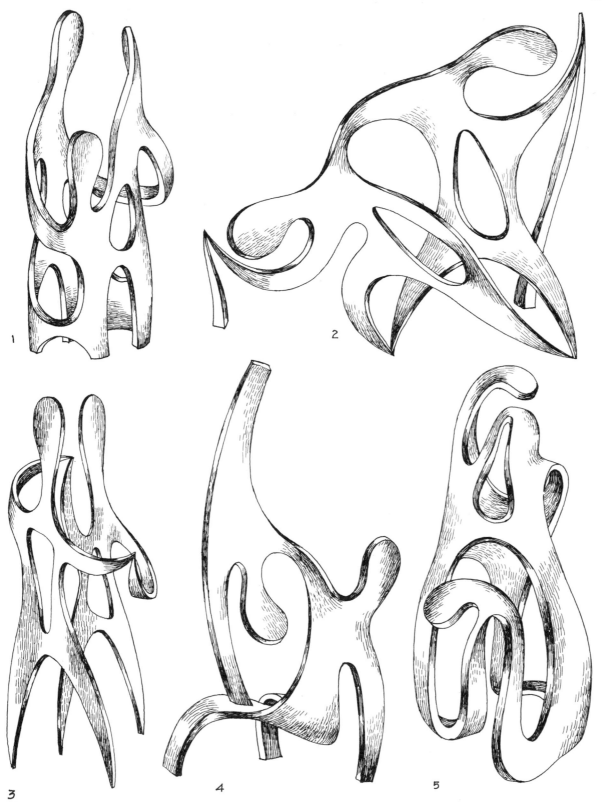

PLATE I **Open-figure compositions, showing thickness variation.**

The single figure in Figure 5 shows a considerable amount of opposition in the directions of the three principal parts of the design. Furthermore, the treatment of the head and base are quite different. The variation thus expressed adds to the over-all interest.

Figure 4, even though two figures are used, has considerably less action than Figure 5. It is evident that mere numbers do not increase the quality of interesting and lively design.

Figures 1, 3, and 6, each using two figures, are more interesting than Figure 4. Incidentally, Figure 6 was inspired by a series of drawings of fishermen handling nets. The sketches were made many years ago and became the themes for many paintings. This use of the material was a much later development. It points up the fact that our drawings, sketches, color notes, and all the things we experience can be and often are of use to us. We cannot always predict when we shall use them nor in what manner, but if we have a record of our impressions, we have that much more material that we can employ.

Figure 2. This three-figure design has only four legs. Two adjacent figures have one common leg, making it possible to eliminate two legs. I have purposely simplified the lower part because too much repetition in the lower portion of the group would have created a rhythm and subdivision of space which would have been altogether too important.

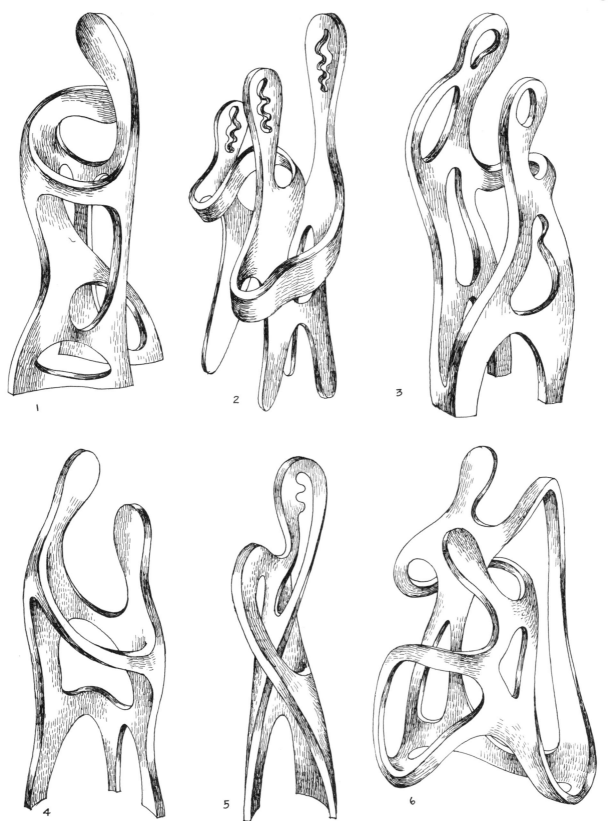

PLATE I

PLATE J **Dancing figures, individually and in com-bination.**

The six single figures along the right edge of this plate were cut from sheet metal, then twisted and bent into shape. These figures illustrate how we can step into space from a plane surface by comparatively simple means.

Figure 1. The figures were cut from sheet metal and shaped. The base was raised by hammering. The two parts were then soldered to form the design.

Figures 2, 3, and 4 were made from blocks of clay. The "jitter-bugs" in Figure 2 try to suggest the nervous energy associated with that kind of dancing.

Figure 3 is a more sedate interpretation of the jitterbug theme.

In Figure 4, the thickness of the two figures suggests slower, less active movement. Notice how the openings rise alternately, beginning with the legs of the shorter figure. This creates diagonal movement which contrasts with the more static vertical figures.

I have found that choosing a theme, such as the dance, music or any other that may interest me, offers a great deal of subject matter that can be expressed in many different ways.

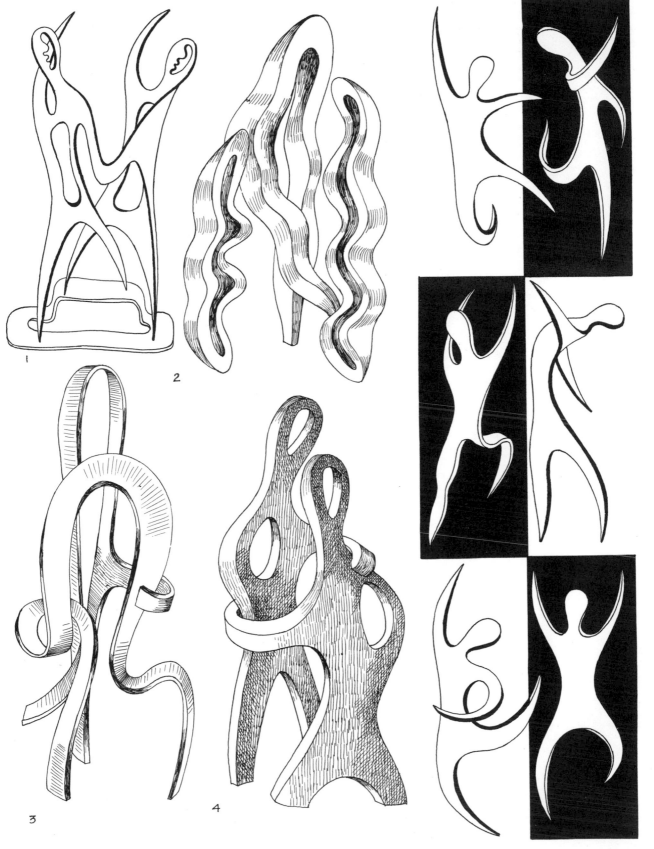

PLATE J

PLATE K **Block and pyramidal derivatives.**

With the exception of Figure 7, the compositions in this plate are essentially pyramidal in their over-all design. The component parts vary in geometric shape, with the prismatic surfaces playing an important role. By a slight change we can transform each composition into a total pyramidal figure.

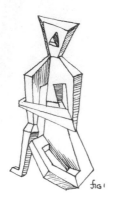

In the example at left (fig. 1) Figure 4 has been changed. The resultant design is not necessarily better or worse if repetition is used throughout. It is important to study the effect of repetition and the best way to do it is by comparison. This calls for doing the same figure in different ways and may become somewhat tiresome. At this point discipline and control have to be exercised.

Using the same basic figure, try several variations, as follows:
1. All plane surfaces (prismatic, pyramidal).
2. All curved surfaces (conical, cylindrical, ellipsoidal).
3. Combinations of plane and curved surfaces.

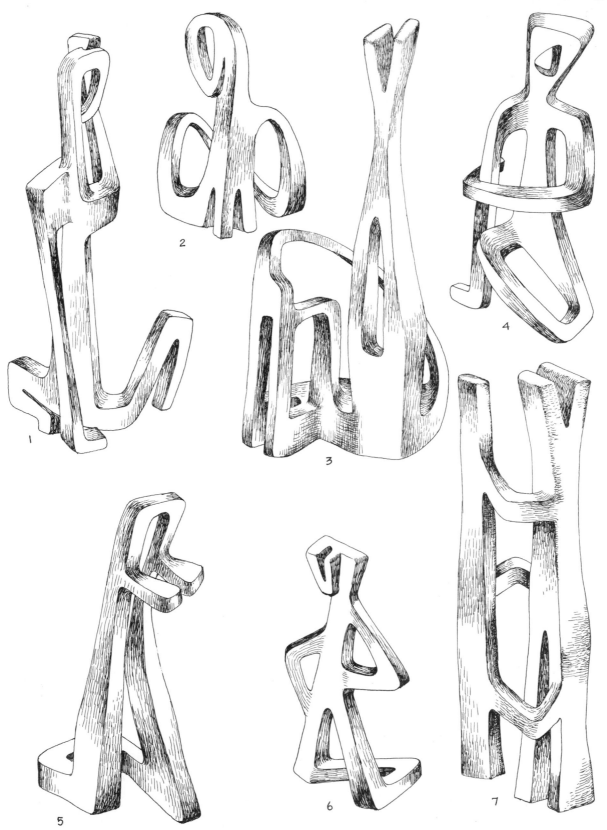

PLATE L **Pyramidal variants with considerable changes in thickness.**

Variation 3 is the most abstract of the five compositions in this group. It is based on a number of studies that I made of two acrobats. (Figure 2 of Plate G and Figure 4 of Plate H are different interpretations of the same theme.) The lower part of the figure stresses plane surface faces slightly rounded at the edges and corners, while the upper part features conical and cylindrical surfaces. There is no sharp division between the two parts; the transition from one to the other is uninterrupted.

The seated figures in Figures 1 and 2 show two different treatments of the same basic model. In Figure 1, the mass weight is almost equally divided between the head and legs, creating less difference between the two parts than in Figure 2. The general pyramidal shape of Figure 2 is more elongated than the pyramidal shape of Figure 1.

Study the differences in effect of the pyramids (figs. 1–4 below), in which each base is the same.

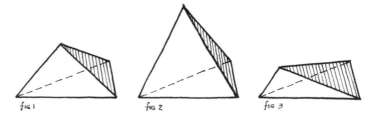

Figures 4 and 5 are somewhat alike in the treatment of the heads, the transition from one figure to the next, the over-all pyramidal shape and the combination of surfaces used.

As the number of figures is increased, the problem of control, flow of line, and integration of the parts becomes more challenging. It is difficult enough to create a satisfying piece of sculpture using only one figure, but when two or more figures are added, we must solve the problem of each individual form as well as the effect of each form on every other one in the design.

Neighboring figures have at times strange effects on each other. Each one considered alone may be quite good, but when assembled, each may lose its effectiveness. This happens in painting as well as three-dimensional design and calls for a great deal of study and experimentation.

PLATE L

PLATE M **Wire-line figures allowing free interpretation of surfaces.**

The eight wire figures in this plate are a set of skeletal forms in which the heads have identifiable geometric shapes. The other parts are treated very simply. The simplification allows the onlooker to imagine his own geometric shapes to round out each design. A desirable quality in any work is the power it can exert in stimulating the viewer to put something of himself and his experience into the work. The onlooker becomes identified with the work in a subjective sense, making it a part of him.

The figures are composed of space curves united by simpler, curved lines. Since surfaces are generated by moving lines and since lines are generated by moving points, we may evolve space figures using the moving point as a start. The resultant lines need not be continuous.

The examples in figs. A and B, below, illustrate the moving-point approach.

fig A

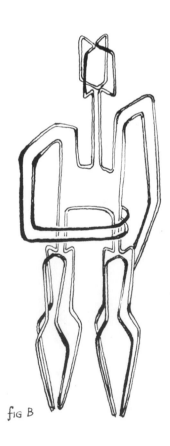

fig B

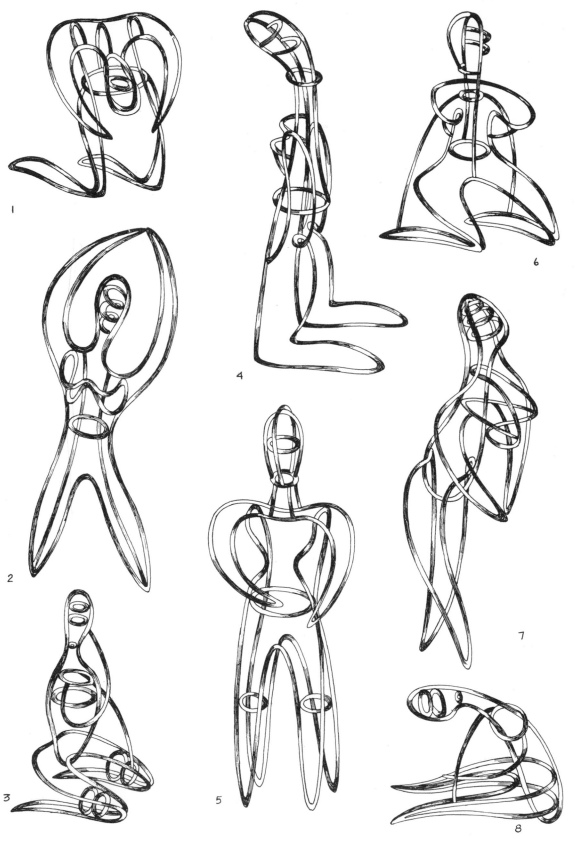

PLATE M

PLATE N **Sheet and wire compositions.**

Figures 2, 3, 6, and 7 represent combinations of continuously flowing lines. Figure 2 uses two separate space curves, each curve being part of the three figures. In the actual space sculpture that I created, the two lines were joined in several places. Otherwise the figures would have toppled over.

Figures 3 and 6 are each composed of three separate continuous line figures. They can be united by soldering, welding, or bending. While each figure is three-dimensional, the over-all space effect is created by effective changes in direction of the component figures. Each individual figure need not be three-dimensional. It is the juxtaposition of the figures which creates the space effect.

Figure 7, which is a composition using two separate continuous line figures, treats each figure with greater emphasis on the three-dimensional mass effect than do Figures 2, 3, and 6.

Figure 5 is a composition of three figures in which each figure combines a sheet surface and a continuous line.

Various interesting combinations of line and surface are possible:
1. Plane continuous line and plane surface (forming one plane).
2. Plane continuous line and curved surface.
3. Space continuous line and plane surface.
4. Space continuous line and curved surface.
5. Plane continuous line and plane surface (not forming one plane).

Figure 1 represents the continuous flow of line in which thickness varies considerably. The changes in thickness, together with the bending of the arms out of the plane, give an interesting three-dimensional effect.

Figures 4 and 8 feature continuity of line with varying thickness. These figures, when compared with the other compositions of this plate, have a greater feeling of mass weight. It would be more accurate in describing Figures 4 and 8 to say that they are made of flowing surfaces.

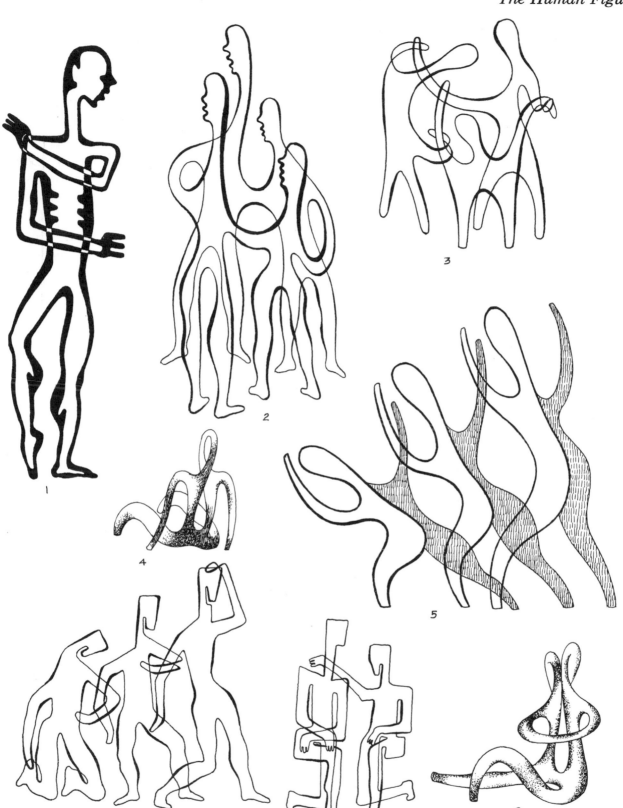

1

2

3

4

5

6

7

8

PLATE N

PLATE O **Musical figures.**

One of my favorite subjects, music, is the theme of these fourteen designs, which were created by me and executed in silver by my wife. Just as in the figures in Plate E of the section on Animal Form, the musicians were evolved from sheet silver and square and round wire. Stepping out of the plane was managed by bending, twisting, and soldering to give an added sense of depth.

The illustrations in this plate have been somewhat simplified. The actual three-dimensional figures are rounded by bending so that they are slightly cylindrical. Just enough bend was used to offset some of the plane surfaces, thus creating more contrast and a greater feeling of the space figure.

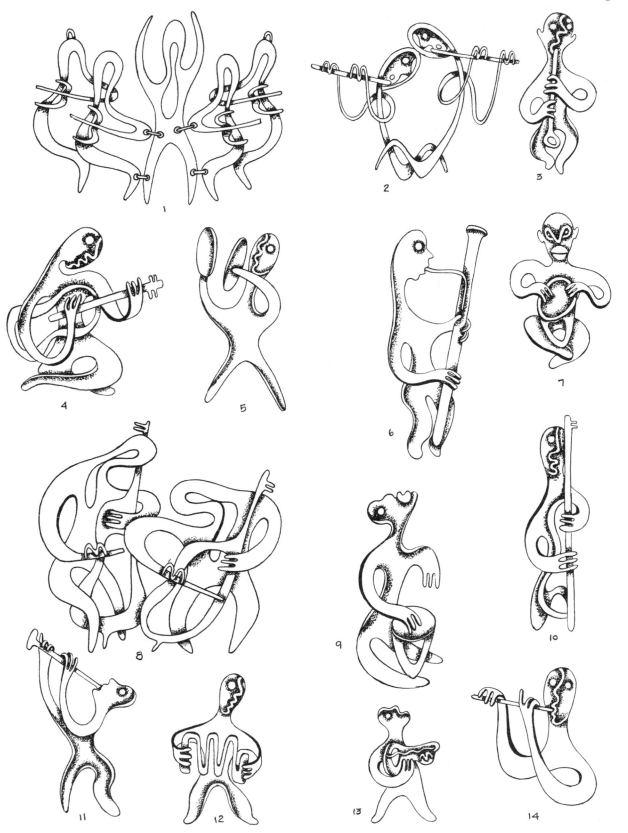

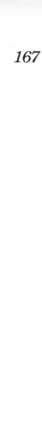

PLATE P Variants showing the interplay of concave and convex surfaces.

Most of the sculptural figures of this plate illustrate, among other things, the interplay of concave and convex surfaces. Transitions of direction in space design may be very sudden or very subtle or a combination of both. In one way or another, they must create an awareness of movement in depth.

The concave surface recedes from the observer, while the convex surface advances towards the observer. The combination of the two helps create dynamic design.

Figures 1 and 2 have only a very sparing use of concave surfaces. The convex surfaces flow into each other smoothly, creating a continuous flowing effect.

Figures 3 and 4 show sharp distinction between adjoining surfaces, creating an effect of angularity.

In the remaining figures of Plate P, the general sculptural use of concave and convex surfaces lies somewhere between the extremes shown in Figures 1 and 2 and Figures 3 and 4.

Of the four different views in Figure 9, 9c is a front view; 9d is a rightside view; 9b is a leftside view; and 9a is a rear view.

PLATE P

Dover Books on Art

AN ATLAS OF ANIMAL ANATOMY FOR ARTISTS, W. Ellenberger, H. Baum, H. Dittrich. The largest, richest animal anatomy for artists in English. Form, musculature, tendons, bone structure, expression, detailed cross sections of head, other features, of the horse, lion, dog, cat, deer, seal, kangaroo, cow, bull, goat, monkey, hare, many other animals. "Highly recommended," DESIGN. Second, revised, enlarged edition with new plates from Cuvier, Stubbs, etc. 288 illustrations. 153pp. 11⅜ x 9.

20082-5 Paperbound $3.00

ANIMAL DRAWING: ANATOMY AND ACTION FOR ARTISTS, C. R. Knight. 158 studies, with full accompanying text, of such animals as the gorilla, bear, bison, dromedary, camel, vulture, pelican, iguana, shark, etc., by one of the greatest modern masters of animal drawing. Innumerable tips on how to get life expression into your work. "An excellent reference work," SAN FRANCISCO CHRONICLE. 158 illustrations. 156pp. 10½ x 8½.

20426-X Paperbound $3.00

ARCHITECTURAL AND PERSPECTIVE DESIGNS, Giuseppe Galli Bibiena. 50 imaginative scenic drawings of Giuseppe Galli Bibiena, principal theatrical engineer and architect to the Viennese court of Charles VI. Aside from its interest to art historians, students, and art lovers, there is a whole Baroque world of material in this book for the commercial artist. Portrait of Charles VI by Martin de Meytens. 1 allegorical plate. 50 additional plates. New introduction. vi + 103pp. 10⅛ x 13¼.

21263-7 Paperbound $2.50

HANDBOOK OF DESIGNS AND DEVICES, C. P. Hornung. A remarkable working collection of 1836 basic designs and variations, all copyright-free. Variations of circle, line, cross, diamond, swastika, star, scroll, shield, many more. Notes on symbolism. "A necessity to every designer who would be original without having to labor heavily," ARTIST AND ADVERTISER. 204 plates. 240pp. 5⅜ x 8.

20125-2 Paperbound $2.00

CHINESE HOUSEHOLD FURNITURE, G. N. Kates. A summary of virtually everything that is known about authentic Chinese furniture before it was contaminated by the influence of the West. The text covers history of styles, materials used, principles of design and craftsmanship, and furniture arrangement—all fully illustrated. xiii + 190pp. 5⅝ x 8½.

20958-X Paperbound $2.00

DECORATIVE ART OF THE SOUTHWESTERN INDIANS, D. S. Sides. 300 black and white reproductions from one of the most beautiful art traditions of the primitive world, ranging from the geometric art of the Great Pueblo period of the 13th century to modern folk art. Motives from basketry, beadwork, Zuni masks, Hopi kachina dolls, Navajo sand pictures and blankets, and ceramic ware. Unusual and imaginative designs will inspire craftsmen in all media, and commercial artists may reproduce any of them without permission or payment. xviii + 101pp. 5⅝ x 8⅜.

20139-2 Paperbound $1.50

PENNSYLVANIA DUTCH AMERICAN FOLK ART, H. J. Kauffman. The originality and charm of this early folk art give it a special appeal even today, and surviving pieces are sought by collectors all over the country. Here is a rewarding introductory guide to the Dutch country and its household art, concentrating on pictorial matter—hex signs, tulip ware, weather vanes, interiors, paintings and folk sculpture, rocking horses and children's toys, utensils, Stiegel-type glassware, etc. "A serious, worthy and helpful volume," W. G. Dooley, N. Y. TIMES. Introduction. Bibliography. 279 halftone illustrations. 28 motifs and other line drawings. 1 map. 146pp. 7⅞ x 10¾.

21205-X Paperbound $2.00

DESIGN AND EXPRESSION IN THE VISUAL ARTS, J. F. A. Taylor. Here is a much needed discussion of art theory which relates the new and sometimes bewildering directions of 20th century art to the great traditions of the past. The first discussion of principle that addresses itself to the eye rather than to the intellect, using illustrations from Rembrandt, Leonardo, Mondrian, El Greco, etc. List of plates. Index. 59 reproductions. 5 color plates. 75 figures. x + 245pp. 5⅜ x 8½.

21195-9 Paperbound $2.25

THE ENJOYMENT AND USE OF COLOR, W. Sargent. Requiring no special technical know-how, this book tells you all about color and how it is created, perceived, and imitated in art. Covers many little-known facts about color values, intensities, effects of high and low illumination, complementary colors, and color harmonies. Simple do-it-yourself experiments and observations. 35 illustrations, including 6 full-page color plates. New color frontispiece. Index. x + 274 pp. 5⅜ x 8.

20944-X Paperbound $2.25

STYLES IN PAINTING, Paul Zucker. By comparing paintings of similar subject matter, the author shows the characteristics of various painting styles. You are shown at a glance the differences between reclining nudes by Giorgione, Velasquez, Goya, Modigliani; how a Byzantine portrait is unlike a portrait by Van Eyck, da Vinci, Dürer, or Marc Chagall; how the painting of landscapes has changed gradually from ancient Pompeii to Lyonel Feininger in our own century. 241 beautiful, sharp photographs illustrate the text. xiv + 338 pp. 5⅝ x 8¼.

20760-9 Paperbound $2.25

THE PRACTICE OF TEMPERA PAINTING, D. V. Thompson, Jr. Used in Egyptian and Minoan wall paintings and in much of the fine work of Giotto, Botticelli, Titian, and many others, tempera has long been regarded as one of the finest painting methods known. This is the definitive work on the subject by the world's outstanding authority. He covers the uses and limitations of tempera, designing, drawing with the brush, incising outlines, applying to metal, mixing and preserving tempera, varnishing and guilding, etc. Appendix, "Tempera Practice in Yale Art School" by Prof. L. E. York. 4 full page plates. 85 illustrations. x + 141pp. 5⅜ x 8½. 20343-3 Paperbound $1.75

VASARI ON TECHNIQUE, G. Vasari. Pupil of Michelangelo, outstanding biographer of Renaissance artists reveals technical methods of his day. Marble, bronze, fresco painting, mosaics, engraving, stained glass, rustic ware, etc. Only English translation, extensively annotated by G. Baldwin Brown. 18 plates. 342pp. 5⅜ x 8. 20717-X Paperbound $2.75

FOOT-HIGH LETTERS: A GUIDE TO LETTERING, M. Price. 28 15½ x 22½" plates, give classic Roman alphabet, one foot high per letter, plus 9 other 2" high letter forms for each letter. 16 page syllabus. Ideal for lettering classes, home study. 28 plates in box. 20238-9 $6.00

A HANDBOOK OF WEAVES, G. H. Oelsner. Most complete book of weaves, fully explained, differentiated, illustrated. Plain weaves, irregular, double-stitched, filling satins; derivative, basket, rib weaves; steep, broken, herringbone, twills, lace, tricot, many others. Translated, revised by S. S. Dale; supplement on analysis of weaves. Bible for all handweavers. 1875 illustrations. 410pp. 6⅛ x 9¼. 20209-7 Clothbound $7.50

JAPANESE HOMES AND THEIR SURROUNDINGS, E. S. Morse. Classic describes, analyses, illustrates all aspects of traditional Japanese home, from plan and structure to appointments, furniture, etc. Published in 1886, before Japanese architecture was contaminated by Western, this is strikingly modern in beautiful, functional approach to living. Indispensable to every architect, interior decorator, designer. 307 illustrations. Glossary. 410pp. 5⅝ x 8⅜. 20746-3 Paperbound $2.25

THE DRAWINGS OF HEINRICH KLEY. Uncut publication of long-sought-after sketchbooks of satiric, ironic iconoclast. Remarkable fantasy, weird symbolism, brilliant technique make Kley a shocking experience to layman, endless source of ideas, techniques for artist. 200 drawings, original size, captions translated. Introduction. 136pp. 6 x 9. 20024-8 Paperbound $2.00

COSTUMES OF THE ANCIENTS, Thomas Hope. Beautiful, clear, sharp line drawings of Greek and Roman figures in full costume, by noted artist and antiquary of early 19th century. Dress, armor, divinities, masks, etc. Invaluable sourcebook for costumers, designers, first-rate picture file for illustrators, commercial artists. Introductory text by Hope. 300 plates. 6 x 9. 20021-3 Paperbound $2.00

EPOCHS OF CHINESE AND JAPANESE ART, E. Fenollosa. Classic study of pre-20th century Oriental art, revealing, as does no other book, the important interrelationships between the art of China and Japan and their history and sociology. Illustrations include ancient bronzes, Buddhist paintings by Kobo Daishi, scroll paintings by Toba Sojo, prints by Nobusane, screens by Korin, woodcuts by Hokusai, Koryusai, Utamaro, Hiroshige and scores of other pieces by Chinese and Japanese masters. Biographical preface. Notes. Index. 242 illustrations. Total of lii + 439pp. plus 174 plates. 5⅝ x 8¼. 20364-6, 20265-4 Two-volume set, Paperbound $5.00

Dover Books on Art

LANDSCAPE GARDENING IN JAPAN, Josiah Conder. A detailed picture of Japanese gardening techniques and ideas, the artistic principles incorporated in the Japanese garden, and the religious and ethical concepts at the heart of those principles. Preface. 92 illustrations, plus all 40 full-page plates from the Supplement. Index. xv + 299pp. 8⅜ x 11¼.

21216-5 Paperbound $3.50

DESIGN AND FIGURE CARVING, E. J. Tangerman. "Anyone who can peel a potato can carve," states the author, and in this unusual book he shows you how, covering every stage in detail from very simple exercises working up to museum-quality pieces. Terrific aid for hobbyists, arts and crafts counselors, teachers, those who wish to make reproductions for the commercial market. Appendix: How to Enlarge a Design. Brief bibliography. Index. 1298 figures. x + 289pp. 5⅜ x 8½.

21209-2 Paperbound $2.00

THE STANDARD BOOK OF QUILT MAKING AND COLLECTING, M. Ickis. Even if you are a beginner, you will soon find yourself quilting like an expert, by following these clearly drawn patterns, photographs, and step-by-step instructions. Learn how to plan the quilt, to select the pattern to harmonize with the design and color of the room, to choose materials. Over 40 full-size patterns. Index. 483 illustrations. One color plate. xi + 276pp. 6¾ x 9½. 20582-7 Paperbound $2.50

LOST EXAMPLES OF COLONIAL ARCHITECTURE, J. M. Howells. This book offers a unique guided tour through America's architectural past, all of which is either no longer in existence or so changed that its original beauty has been destroyed. More than 275 clear photos of old churches, dwelling houses, public buildings, business structures, etc. 245 plates, containing 281 photos and 9 drawings, floorplans, etc. New Index. xvii + 248pp. 7⅞ x 10¾. 21143-6 Paperbound $3.00

A HISTORY OF COSTUME, Carl Köhler. The most reliable and authentic account of the development of dress from ancient times through the 19th century. Based on actual pieces of clothing that have survived, using paintings, statues and other reproductions only where originals no longer exist. Hundreds of illustrations, including detailed patterns for many articles. Highly useful for theatre and movie directors, fashion designers, illustrators, teachers. Edited and augmented by Emma von Sichart. Translated by Alexander K. Dallas. 594 illustrations. 464pp. 5⅛ x 7⅛.

21030-8 Paperbound $3.00

Dover publishes books on commercial art, art history, crafts, design, art classics; also books on music, literature, science, mathematics, puzzles and entertainments, chess, engineering, biology, philosophy, psychology, languages, history, and other fields. For free circulars write to Dept. DA, Dover Publications, Inc., 180 Varick St., New York, N.Y. 10014.